IMAGES
of America

LAKE ERIE
WINE COUNTRY

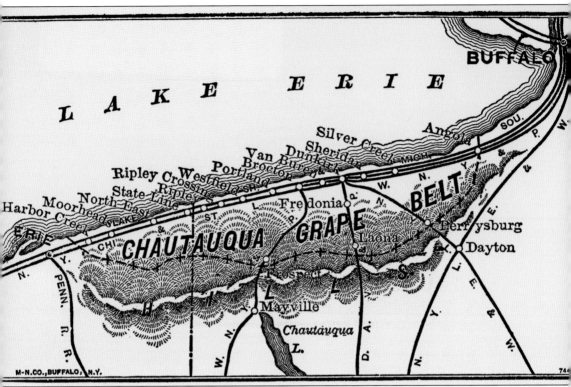

This map of the Lake Erie Wine Country grape region originally appeared in a North East, Pennsylvania, directory in the 1800s. It was created by Matthews-Northrup & Co., Art-Printing Works of Buffalo, New York. It is the quintessential grape belt map and has appeared in other publications over the years. The grape-growing region, approximately 60 miles long from Harborcreek, Pennsylvania, to Silver Creek, New York, was developed in the late 1880s and remains about the same in vineyard acreage. (North East Historical Society.)

ON THE COVER: Seen here are a handsome team of horses, a little farm dog, farm hands, and female grape pickers (some of whom look as if they had a long day), and a handsomely dressed gentleman—standing in the center—who is probably the owner of this North East Concord grape farm at the turn of the 20th century. This is a snapshot of a fairly warm harvest day in times gone by. (North East Historical Society.)

IMAGES
of America

LAKE ERIE
WINE COUNTRY

Jewel Leigh Ellis

ARCADIA
PUBLISHING

Published by Arcadia Publishing
Charleston, South Carolina

Printed in the United States of America

Library of Congress Control Number: 2013957746

For all general information, please contact Arcadia Publishing:
Telephone 843-853-2070
Fax 843-853-0044
E-mail sales@arcadiapublishing.com
For customer service and orders:
Toll-Free 1-888-313-2665

Visit us on the Internet at www.arcadiapublishing.com

For Jeremiah and Nicole, grape pickers with a love
of history and great futures before them

CONTENTS

ACKNOWLEDGMENTS

I am grateful to many people who helped me gather material for this book. Such a large undertaking requires the cooperation of many. My sincere thanks go to the following: Kathie and Bob Mazza, Kathy and Nick Mobilia, Vanessa Mazza, Nancy Hirsch, Jennifer and Fred Johnson, Bethany Margolis, Dick Tefft, Charles Wagner, Nancy Nixon, Anne Behling, Jeff Ore, Cindy and John Moorhead, Michael Moorhead, Pat Federici, John Piper, Charlene Kerr, Catherine McClure, Dawn Ellis, Robert Lorei, Keith Sowers, John Paul Wolfe, Sherri Towell, Jim Boltz, Jim King, Brent Roggie, Heather Perkins, Don Buchholz, Jeff Buchholz, Mary Mancuso, Vincent Martonis, Sam Best, Doug Moorhead, Roy Orton, Chuck Pfadt, and Debbie Lam. A special thank-you is reserved for my historic "fact checker" and last-minute image provider, grape belt historian John Slater. Also, I would like to thank Lynne Clement of Lake Erie Cottages and Daniel Smith at Fairway Suites at the Peak for providing exquisite, tranquil places in which I could work peacefully. I also send a warm thank-you to my patient Arcadia acquisitions director Abby Henry Walker. To my family who endures my taking on many crazy projects: thank-you. To everyone else who assisted in ways both big and small, please know that I am very grateful for your help.

INTRODUCTION

Lake Erie Wine Country is a new name given to a wine and grape region that has been evolving for more than 160 years. Known as the Concord Grape Belt, the Chautauqua-Erie Grape Belt, the Lake Erie Grape Region, and a few other names, Lake Erie Wine Country exists in a region that boasts 25 wineries and 30,000 acres of grape vineyards. It is approximately 60 miles long and one and a half to five miles wide, stretching from Harborcreek, Pennsylvania, to Silver Creek, New York, along the southern shore of great Lake Erie. It is the largest grape-growing region east of the Rockies in the United States, and it is the largest and oldest Concord grape–growing region in the world.

The southern shore of Lake Erie seems an unlikely place to grow quality grapes. It is only a few miles from Canada, as far north as you can get in that area of the United States. It is famous for long, cold winters and lake-effect snow. Yet the grapes not only survive, they thrive, and the world has taken notice.

The long grape and wine history of the region begins in the Ice Age. At that time, glaciers descended from the north, gouging out great trenches and bringing with them tremendous quantities of fertile soil and gravel, depositing it all along the Lake Erie shore. The well-drained gravel-loam soils are one aspect of the region's excellent terroir; the other is the moderating effect of Lake Erie on spring and fall temperatures. A lake warmed by months of summer sun will stay warm long into the fall, thus warming the lakeshore. A frozen or very cold lake keeps spring temperatures slightly cooler for a longer period of time. The lake also provides constant breezes, which are beneficial because they prevent cold air from settling in lower-lying areas during threatening periods of frost, and they maximize the moderating effect of the lake's warm waters. All of these natural features combine to create the perfect growing environment for healthy vineyards and premium wines.

Native varieties of grapes, such as Isabella and Catawba (both thought to have originated in South Carolina), were first planted in the region in the early 1800s. After the Concord grape was created by Ephraim Bull in Concord, Massachusetts, in 1849, it was brought to Chautauqua County, New York, by relatives of Deacon Elijah Fay, the man who is credited with planting the first grapevines in the region. During the harsh winter of 1872–1873, most grapevines were destroyed, but the hearty Concord survived. Farmers all along the lakeshore from Harborcreek, Pennsylvania, to Silver Creek, New York, planted Concord grapes that were used as table grapes, sometimes wine, and—beginning in the late 1890s—in "unfermented wine," also known as grape juice. The Welch Grape Juice Company moved to Chautauqua County in 1897 and changed the region forever.

Individuals such as Elijah Fay himself began making wine here in the 1830s. Commercial wineries existed in Lake Erie Wine Country as early as the 1850s. The Brocton Wine Cellars in Brocton, New York, was opened in 1859 and the South Shore Wine Company in North East, Pennsylvania, opened in 1864. Wineries came and went during the grape boom at the end of

the 19th century—some faring better than others—but Prohibition generally put an end to the wine industry in 1920.

While the juice industry thrived over the decades for the most part, the wine industry struggled along in New York and Pennsylvania for decades following the 1933 Repeal Act until a few industrious and visionary young men decided the future of the grape region belonged to the wine industry. Frederick S. Johnson of Westfield, New York, and Douglas P. Moorhead Jr. of North East, Pennsylvania, began to tear out old Concord vineyards around 1960, replacing them with well-known premium wine grapes, including both French-American hybrids and European vinifera varieties.

Moorhead and others had to fight to get the State of Pennsylvania, which retained control over all aspects of alcoholic beverages following the repeal, to allow commercial wineries to open. Their efforts led to the passing of the Pennsylvania Limited Winery Act of 1968, which allowed wineries to sell their wines directly to consumers in limited quantities. Moorhead opened a winery he called Presque Isle Wine Cellars the following year, with Penn Shore Vineyards in North East receiving its license on the same day. Both wineries are still open today.

Since the State of New York had allowed wineries to operate following Prohibition, Johnson had opened a winery in Westfield in 1961. However, the New York Farm Winery Act of 1976 allowed individual grape farms to establish small wineries with limited wine production. It also gave incentives to growers to open wineries. Passage of both laws sparked the creation of a chateau industry whose wines rival the quality of premium vintages throughout the world.

During the late 1980s, New York wine regions began to see the benefit of marketing their wineries together, in groups that became known as "wine trails." The Chautauqua Wine Trail was created in the early 2000s by Johnson Estate Winery, Merritt Estate Winery of Forestville, and Woodbury Vineyards Winery in Fredonia. In 2003, they recognized that tourists barely notice the state line that severs the natural grape region, so they invited the Pennsylvania wineries to join the organization. It then became known as the Chautauqua-Lake Erie Wine Trail. The name of the wine trail was changed again in early 2011 to Lake Erie Wine Country, a name that encompasses all the region has to offer, from the wineries to the beautiful scenery, the quaint small towns, lodging and dining facilities, attractions, beaches, and the rich history of the region.

Today, Lake Erie Wine Country produces wines for all tastes, from fruity native Labruscas and exquisite French-American wines to European-style wines. The styles produced here are unique and diverse, resulting in widespread consumer enthusiasm. Many of the wines, particularly the whites, compete with—and often beat—those of competitors on an international stage.

One

CHAUTAUQUA COUNTY, NEW YORK GRAPE INDUSTRY

The first grapevines in Chautauqua County, New York, were planted in 1818 by Deacon Elijah Fay, a native of Massachusetts who moved to Salem Cross Roads (now Brocton) in 1811. Fay began experimenting with the Fox grape variety from his home state, but the vines failed to thrive. In 1824, he purchased some Isabella and Catawba grapevines from the Long Island region, and they were able to withstand the long, cold winters.

The first commercial vineyard in Chautauqua County was planted by Fay's son Joseph in 1851. Fay's nephew Lincoln is widely credited as being the man responsible for introducing Ephriam Bull's Concord grape to the region in the late 1850s.

Only about 500 acres of Concord grapes were being harvested in the Chautauqua-Erie Grape Belt in 1870, but within a decade, the acreage would grow to about 14,000. At this time, it appears there was not a large enough market for grapes being produced, and the fruit's value declined greatly. Shipping of grapes was problematic because the fruit often got crushed in the process. The invention of the Climax basket in Ohio in 1867 helped turn things around, and the shipping of table grapes to faraway cities became profitable. Shipping to very distant locations began in 1875 and further stimulated the grape industry.

In 1897, the Welch Grape Juice Company moved to Westfield, New York, thus changing the region forever. The economic impact of such a company cannot be understated. The history of Welch's is rich—so rich that it has its own chapter in this book. Nearly 50 other juice processing companies opened in the region over the next few decades, some lasting much longer than others.

In 1960, agricultural expert Frederick S. Johnson Sr. returned to his hometown of Westfield and saw the potential for the region's wine industry. He tore out many acres of cherry and apple orchards to plant French hybrid grapes for winemaking. The fabric of the grape industry started to change, and over the next five decades, several wineries would open in Chautauqua County and plant their own wine grapes.

Chautauqua County still produces the majority of New York's grapes. With over 20,000 acres of grapes and several wineries, the grape culture is as pervasive as it was at the turn of the 20th century.

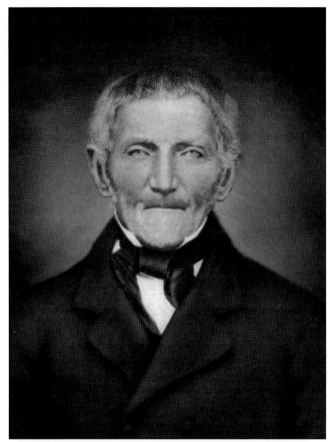

Deacon Elijah Fay worked for many years to find a grape that would thrive in the long, cold winters on Lake Erie's southern shore. Fay planted grapes as early as 1818 but was not successful until he planted Isabella and Catawba varieties in 1824. His relatives planted the delicious and hearty Concord in the 1850s. Fay is revered in the region and, as seen in the photograph below, is celebrated as someone who brought positive, permanent, and profitable change to an agricultural region. The photograph, taken during a 1963 Westfield parade, shows a float dedicated to the memory of Fay. A proud resident dressed up as Fay, and the banner reads, "Elijah Fay–First Grape Vines–1824." (Left, Johnson Estate Winery, Westfield, New York; below, Patterson Library.)

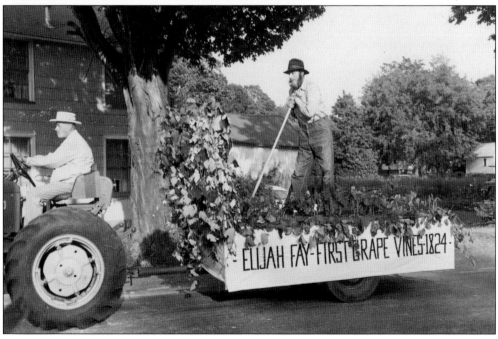

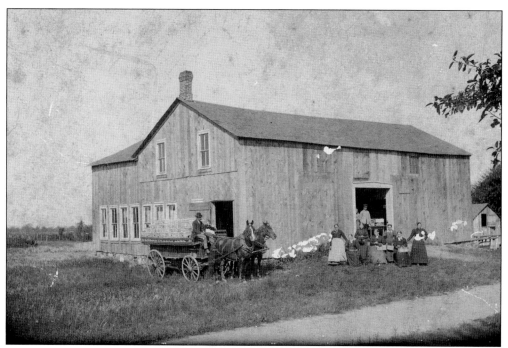

Grape vineyards were plentiful in Chautauqua County, New York, by the turn of the 20th century. This is a photograph from the year 1900 of the Sachse Farm on Hardenburg Road in Westfield. A notation reads that it is Johanna Sachse in the barn and Frank Franz with Leonard on the wagon. (Patterson Library.)

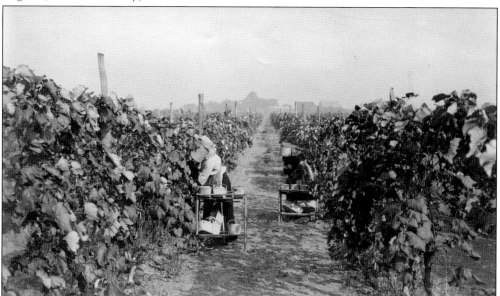

Grape pickers are visible here at the turn of the 20th century on the farm of Frederick W. Johnson in Westfield, New York. Chautauqua County's early commercial vineyards were primarily Concord grapes, developed by Ephriam W. Bull of Concord, Massachusetts. Horace Greeley enthusiastically declared that the new varietal was "the grape for the millions." This prophesy proved true. (Johnson Estate Winery, Westfield, New York.)

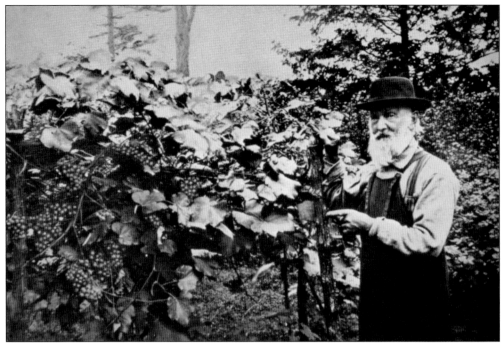

Ephriam W. Bull, seen here in 1856, was born in Boston in 1805. He experimented for 37 years and tested nearly 22,000 seedlings in Concord, Massachusetts, before he successfully grew the Concord grape. Even with the introduction of many varieties of wine grapes, the majority of grapes in the Lake Erie Wine Country region are still Concord grapes. It is the largest and oldest Concord grape region in the world. Although Bull received some headlines in the press, he earned very little money for his Concord grape creation. (Welch Archives.)

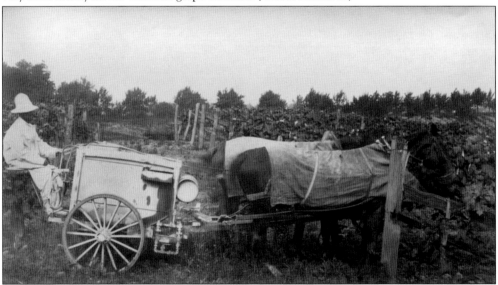

Chautauqua County's grape rows are nine feet wide. If one wonders why that is, this photograph gives that answer. Nine feet is the space needed to fit two horses side-by-side with room enough to maneuver down the rows. These two horses are wearing protective gear, as they are pulling an early fertilizer or pesticide sprayer in the early 1900s. (Johnson Estate Winery, Westfield, New York.)

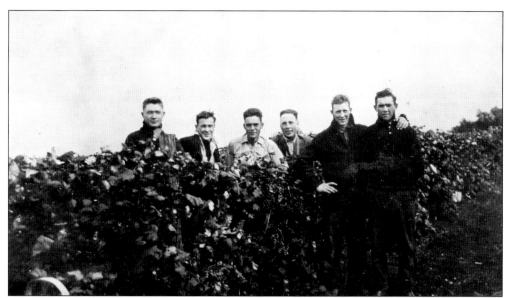

Beneath this photograph is a handwritten caption that reads, "Six Pennsylvania Lads." Perhaps they were tourists, or maybe they visited the Westfield farm to help pick the ripe Concord grapes hanging on the vines as the baskets suggest. (Patterson Library.)

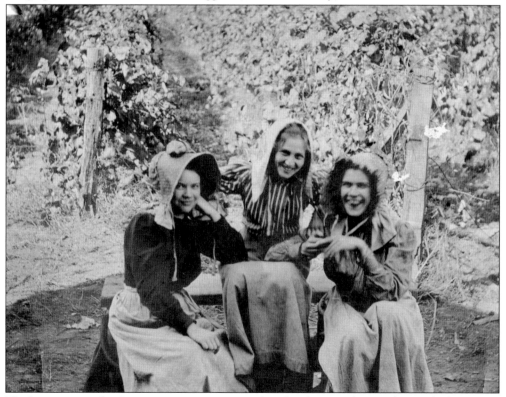

The bonnets worn by these young women suggest that the photograph was taken in the late 1800s. Women were employed to tie grapevines, pick grapes, and pack them for shipment. They also worked in the many basket factories that existed in the region during that period. (Patterson Library.)

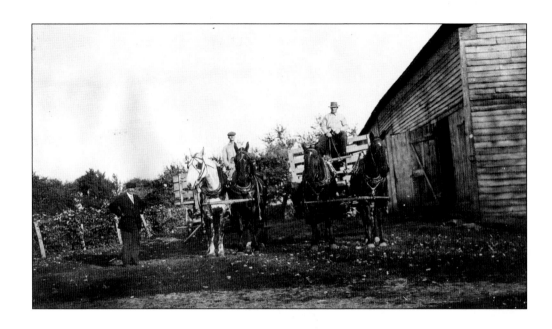

These grape growers paused for a photo opportunity after they loaded their wagons with fresh grapes. Once grapes were picked, they were often packed in the vineyard. Sometimes, however, the fruit was transferred to a building for sorting and packing, particularly on large farms. Large doorways with either sliding or hinged doors allowed wagons piled high with baskets whether empty or full to move in and out. Accompanying the photograph below is a notation that reads, "Going to the station." (Patterson Library.)

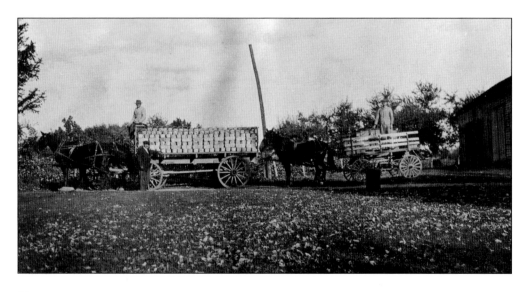

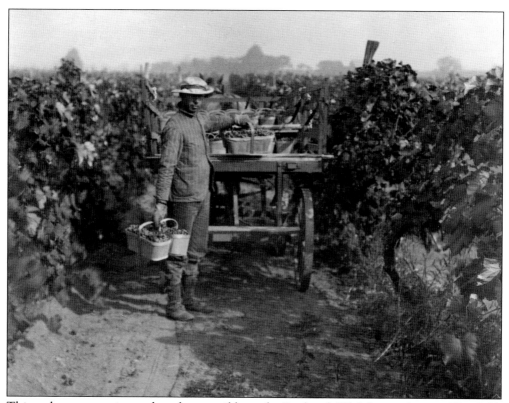

This rather sporty vineyard worker, possibly at the Frederick W. Johnson farm in Westfield, demonstrates his grape-picking skills in the early 1900s. In 1903, due to the presence of the Welch Grape Juice Company, farmers were paid about $20 per ton of grapes. In 1907, the price averaged $40 a ton. Prices fluctuated but rose steadily to $107 in 1918, and by 1920, farmers were receiving $130 per ton. (Johnson Estate Winery, Westfield, New York.)

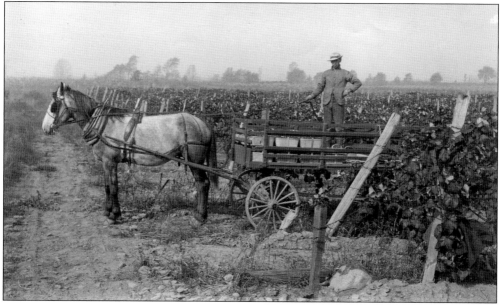

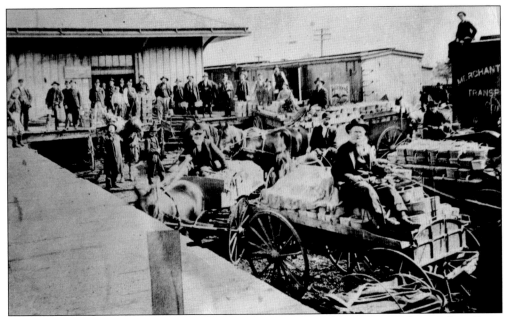

An overabundance of grapes in the 1870s compelled growers to ship grapes to other markets. Jonas Martin of Brocton reasoned that they could profit if they could fill railcars with large quantities of grapes. In 1877, he successfully shipped the first carload of grapes from Chautauqua County to Philadelphia. It was the beginning of an important era. This pre-1903 photograph shows growers with their grapes at a busy railroad depot. (Patterson Library.)

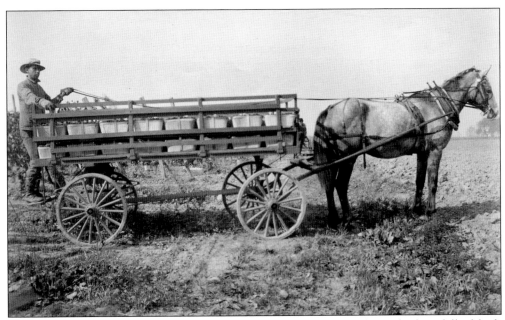

This vineyard worker is in the process of loading his wagon with Climax baskets full of fresh grapes before heading to the train depot. The photograph was likely taken around 1900. (Johnson Estate Winery, Westfield, New York.)

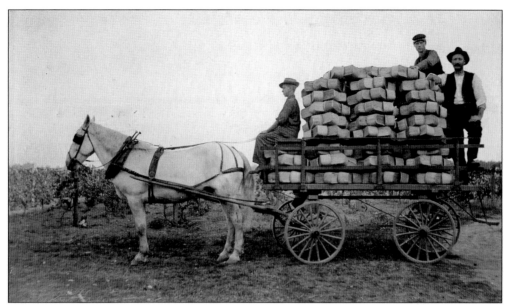

A load of empty Climax baskets are being taken to either a vineyard or a packinghouse during a late-1800s harvest. Early grape shipping was problematic because grapes were often crushed during the process. In 1867, Orrin Stray, a basket maker and vineyard owner from Euclid, Ohio, designed the Climax baskets with a solid bottom and reinforced band around the top. A solid lid prevented crushing and allowed stacking. Stray's basket revolutionized the table grape industry. (Moorhead Farms.)

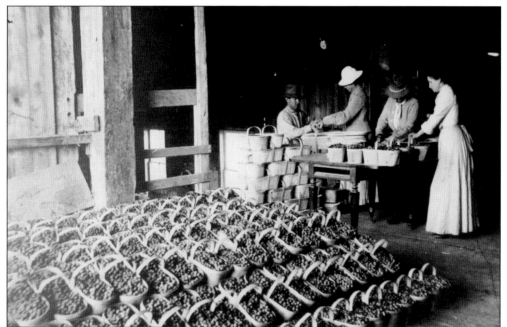

These women are packing delicious Concord grapes at the E.D. Morse Packing House. Grapes were placed in the Climax baskets then allowed to settle before the lids were placed on them. The lids allowed the grapes to be transported without being crushed. It was a major shipping improvement that contributed to the success of the table grape industry. (Patterson Library.)

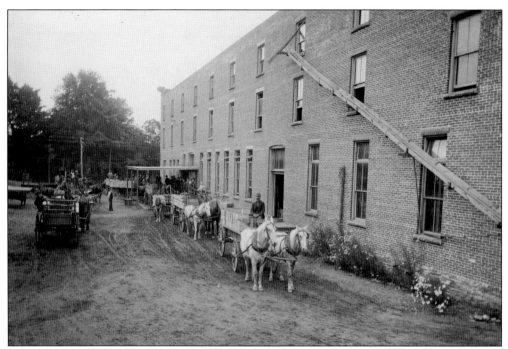

This photograph was taken during the harvest of either 1904 or 1905. Growers carefully stacked their full Welch crates onto wagons and pulled them to Welch Factory No. 1 in Westfield, New York. The building would later be used as the Welch Company print shop. (Patterson Library.)

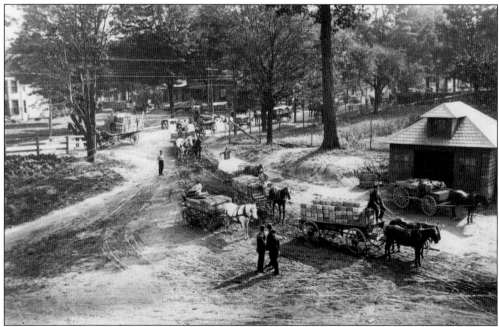

Each harvest season, area grape growers loaded their Welch crates onto their wagons and headed up Portage Street to Welch Factory No. 2 in Westfield, New York. The Welch Company never charged farmers for the wooden Welch crates unless they were damaged or lost. Growers would take full boxes to the plant and return to their farms with empty boxes, ready to refill. (Patterson Library.)

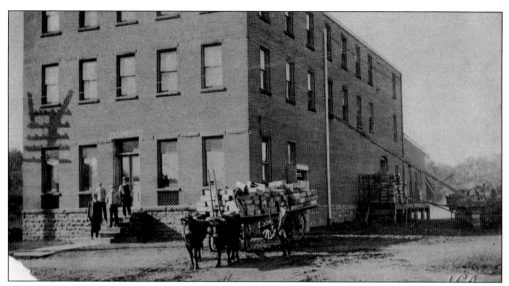

The Welch Company was the largest and most famous grape juice company, but there were many others. In 1910, the Armour Grape Juice Company purchased the Fenner Grape Juice Company, which was located in Westfield, New York, on the west side of Franklin Street, between the Nickel Plate Railroad tracks and English Street. The Fenner Company had been established by a chemist named Dr. Byron Fenner in 1898. It was originally called the Chautauqua Fruit & Grape Juice Company until Fenner sold it in 1908. At that time, it became known as the Fenner Grape Juice Company. The original structure (above) burned in 1918, and the Armour Company rebuilt it (below). (Both, Patterson Library.)

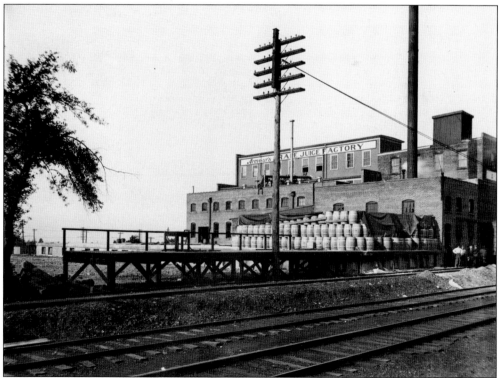

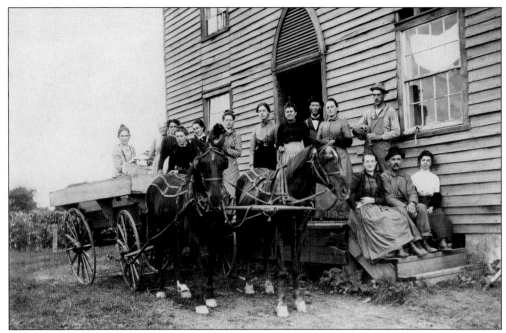

This is the R.D. Fuller Packing House in Brocton, New York. Ralph D. Fuller was the first to vertically integrate his operation, from growing the grapes, packing his own grapes and packing the grapes of others for shipping, shipping carloads of Concords, and producing wine at his Fuller & Skinner Wine Company. (Grape Belt Resource Network Archive.)

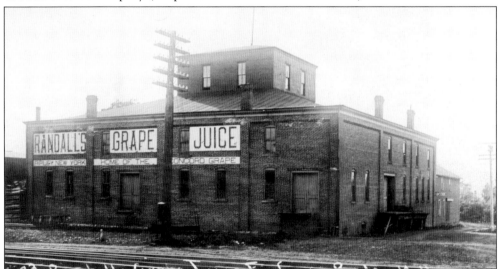

Fred N. Randall was a skilled marketer and astute businessman. He started out producing "pure native wines" at his Chautauqua Wine Company in Ripley, New York, but soon expanded to produce award-winning juice at his Chautauqua Fruit Company. He eventually concentrated on juice production at the Randall's Grape Juice Company. Unfortunately, he passed away quite young, and upon his death, his son sold the facility to the United Fruit Company, which only lasted a couple of years before going out of business. The photograph depicts the Randall's Grape Juice processing plant and the subsequent warehouse addition along the Lake Shore & Michigan Southern Railroad tracks in Ripley, New York. (John T. Slater Collection.)

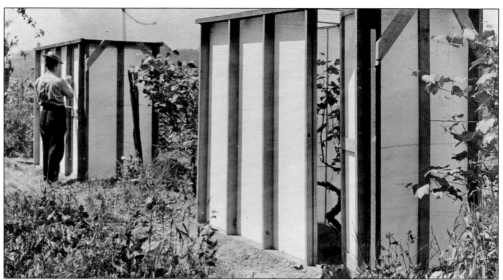

These are spray huts used to house grapes that were then sprayed with various experimental substances. Fred Johnson and his colleagues executed many experiments over many years to develop fertilizers, pesticides, and fungicides that were safe and effective for grape farmers. During the seasons of 1914, 1915, and 1916, extensive research was conducted to establish a means of controlling the dreaded grape berry moth. (Johnson Estate Winery, Westfield, New York.)

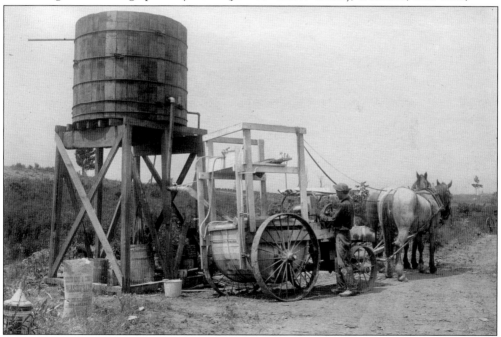

Before there were tractors, there were horses and carts. Chemicals for the grapes were mixed in the tank and gravity assisted the farmer in filling the tank on the cart so it could be sprayed on the grapes. If one looks closely at the bottom left of the photograph, one will see that the burlap bag contains lime. This suggests that perhaps these workers were preparing a Bordeaux mixture consisting of copper and lime, which was used as a fungicide at the time. (Johnson Estate Winery, Westfield, New York.)

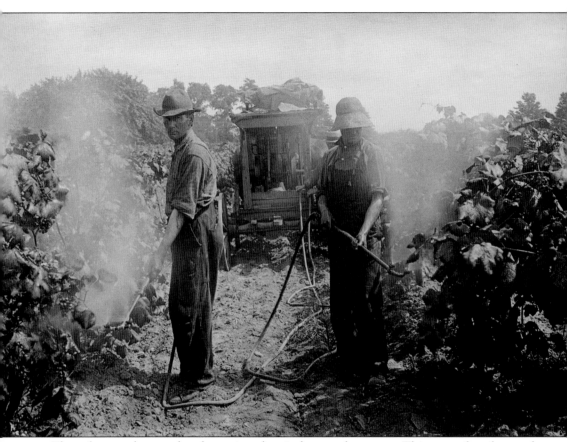

These farm workers are hand-spraying chemicals onto the grapes. This was referred to as the "trailer method" of spraying grapes. Horses are pulling the cart carrying the container of fertilizer, pesticide, or fungicide, and the sprayer itself was gasoline operated. New machines to assist with this messy process would quickly be developed. (Johnson Estate Winery, Westfield, New York.)

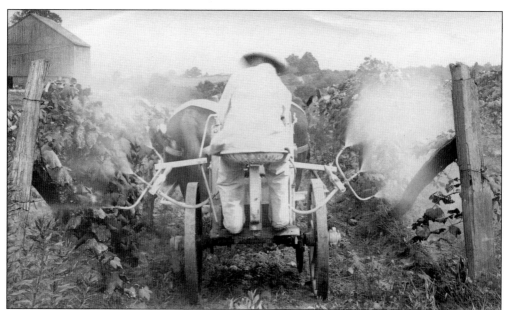

Carefully rigged hoses and spray nozzles allowed farmers to spray fertilizer on the grapes while riding on the horse-pulled tank cart. This was called the set-nozzle method of spray application. The nozzles were set at careful angles and at varying heights to force the spray as far as possible under the leaves. (Johnson Estate Winery, Westfield, New York.)

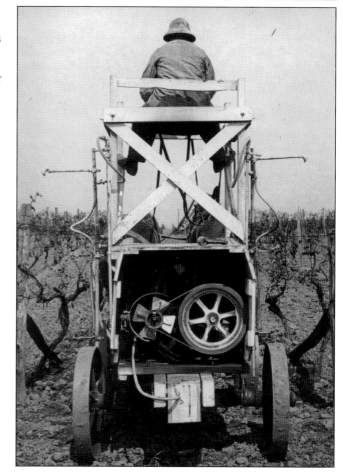

In an effort to put the farmer above the chemicals, a seat was built on top of the spray tank. This gasoline-operated sprayer is being pulled by horses. (Johnson Estate Winery, Westfield, New York.)

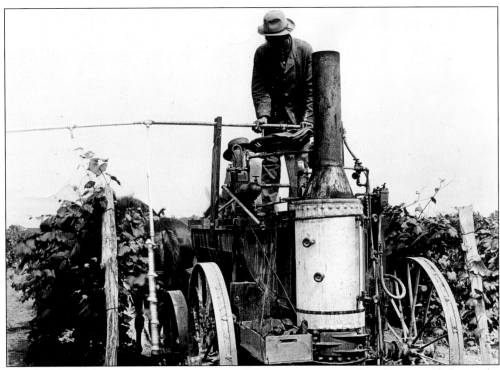

This sprayer appears to be different than the others. One can see the tubes extended over the grape rows with spray nozzles pointing downward. This gasoline-powered sprayer was likely used in the first decade of the 1900s. (Johnson Estate Winery, Westfield, New York.)

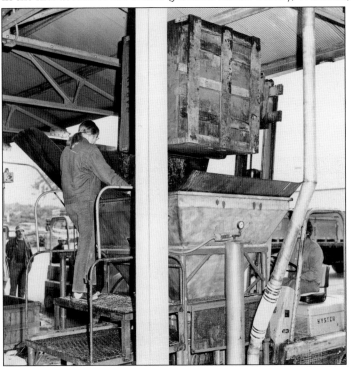

Grape growers began to realize the importance of working together to help maintain control of the industry and ensure fair prices. Cooperatives were started and ended and started again, and eventually, the growers integrated processes and established a strong, efficient, long-lasting industry. This September 1975 photograph shows workers at the Grower's Co-op Hall emptying grapes recently delivered by the Steve Baran Farm into a collection hopper. (Patterson Library.)

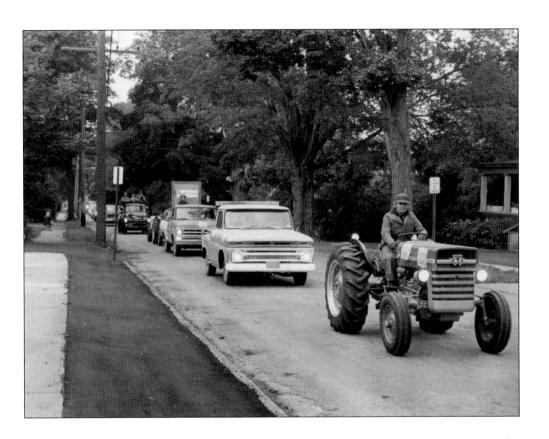

Grape growers struggled from the very beginning to get a fair price for their grapes. Establishing co-ops throughout the decades proved beneficial, but in 1974 regional farmers stood together to press for open-door negotiations for grape prices. The second truck displays a sign that says, "Don't squeeze farmers, squeeze grapes." The photograph below, also from 1974, shows workers on strike at the Fredonia Products Company that made Star Wine. One of the signs indicates that the growers sought 12¢ per pound of grapes, or they would "let 'em hang." (Patterson Library.)

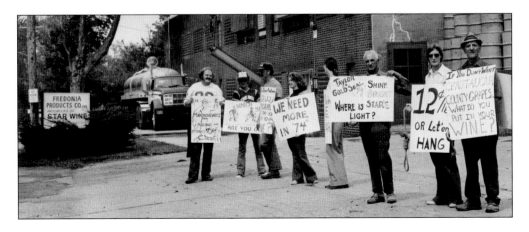

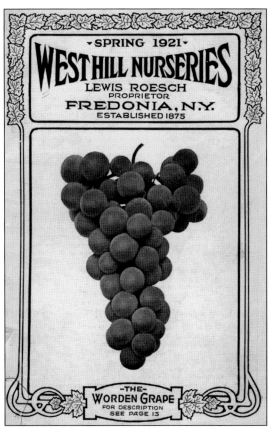

Grapes were not indigenous to northern Chautauqua County, so as viticulture began to develop along the south shore of Lake Erie, vines had to be imported from other areas—most notably from the Long Island grape-growing region. With the growth of the grape industry in the late 19th century, however, Fredonia, New York, became a major center for the propagation and distribution of grapevines. Three local nurserymen, T.S. Hubbard, Lewis Roesch, and George Josselyn, dominated the business and all became very successful in providing grapevines and orchard trees to farmers and growers, as well as general nursery stock to the public. The photograph at left is the Lewis Roesch & Son Westhill Nursery catalog cover from 1921. Lewis Roesch was known to be painstaking, reliable, and responsible. It was written that "the trees and plants purchased of him always gave satisfaction in every way." In the photograph below, George Josselyn (far right with cane) poses with his nursery crew on the company truck. (Above, John T. Slater Collection; below, Darwin R. Barker Historical Museum.)

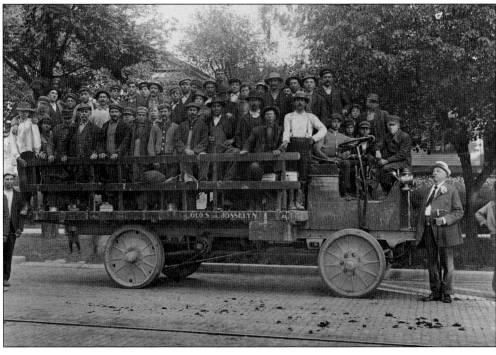

Two

Erie County, Pennsylvania Grape Industry

While Deacon Elijah Fay and then his family were busy establishing the grape industry in Chautauqua County, New York, the nearby agricultural town of North East, Pennsylvania, was poised to continue the growth of the grape belt along the shore of Lake Erie. The first grapes in Erie County, Pennsylvania, were actually grown in the Girard and Springfield areas for small wine operations before 1850. The first commercial vineyard was planted by John French at Moorheadville (between North East and Harborcreek) in 1843.

Credit for establishing the grape industry in Erie County, Pennsylvania, is generally given to William Griffith. He was born in 1816 and raised in Pomfret, New York, very near Fay's homestead. He moved to North East in 1840. An influential and driven man, Griffith realized the soil and climate in North East was very similar to that in the Chautauqua region, so he and his partner, Samuel Smith Hammond, planted North East's first commercial vineyard on what is now Middle Road.

Griffith was a town justice who served as borough attorney. He also helped found the National Bank of North East, served on the town council, helped establish the Erie & North East Railroad in 1852, and influenced the building of the Methodist seminary, which is now a branch campus of Mercyhurst University. All the while, Griffith extolled the virtues of growing grapes and encouraged area farmers to plant vineyards.

Soon there was an overabundance of grapes for the available market, so Griffith decided to build a winery. His winery would become the South Shore Wine Company, still a landmark in North East.

In the 1890s, George Blaine began making grape juice on a small scale. In 1909, William Walker—with the financial backing of his father, Francis—built what was at the time the world's largest juice processing plant in North East. Welch's purchased the plant in 1911. Several other juice and packing plants opened in the North East area, and there were also a growing number of wineries. Although Prohibition virtually eliminated the town's wineries, the limited Winery Act of 1968 allowed commercial wineries to open. Today, there is a great variety of wine grapes in North East and over a dozen wineries.

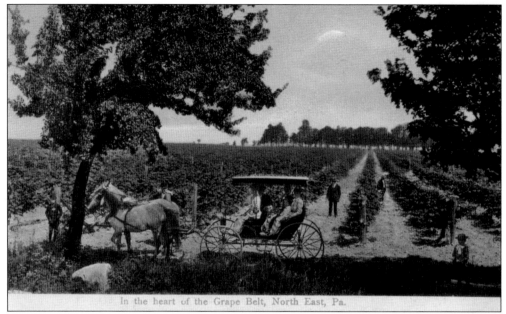

A picture-perfect 1905 postcard shows an ideal scene "In the heart of the Grape Belt, North East, PA." The first grape vineyards in North East were planted by William Griffith and Samuel Smith Hammond between 1847 and 1850. In 1859, the *Erie Observer* reported that "the flourishing village of North East, in this county, is becoming somewhat famous as a grape producing locality." (North East Historical Society.)

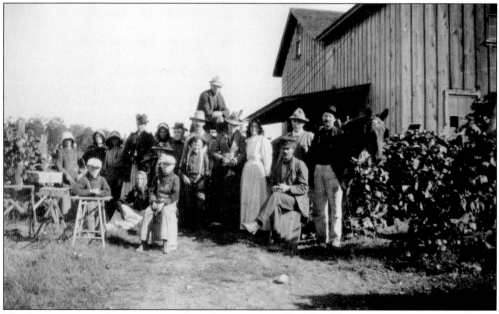

The first commercial grape vineyard on the western end of the Chautauqua-Erie Grape Belt was planted by John French in Moorheadville. This began the development of hundreds of acres of grapes in the vicinity, many of which would be acquired by, or planted by, the Moorhead family. The caption on this photograph reads, "At the Grape House, 1900." A note on the photograph reads, "Probably Moorheads." (North East Historical Society.)

Here is another photograph from 1900 upon which it reads, "Grape House Gang." It was supposed by some historian along the way that this photograph was also taken at the Moorhead Farm. (North East Historical Society.)

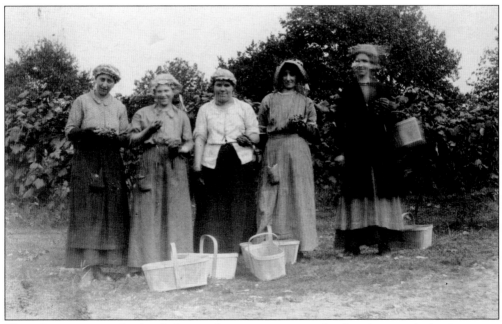

These five women took a break from picking grapes to pose for this photograph that became a postcard, dated 1905. (North East Historical Society.)

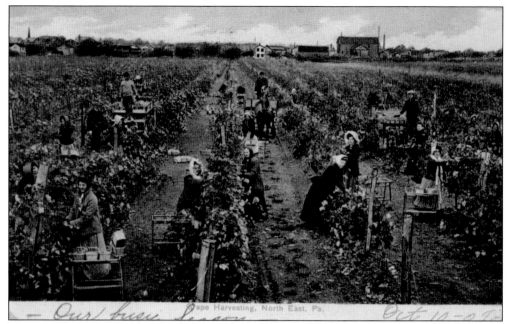

This postcard, postdated 1907, depicts harvest time at the George Blaine Vineyard, located between Grahamville and Clay Streets in North East, Pennsylvania. The photograph was shot facing north, and on the horizon one can see the Blaine Farm barns and parts of the Eureka plant. (North East Historical Society.)

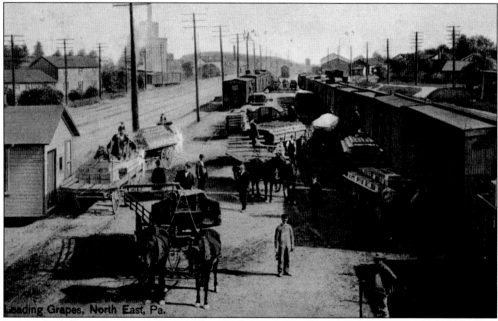

Postmarked 1908, this postcard was taken looking eastward toward Pearl Street in North East. During each fall harvest, the train station teemed with growers, shippers, buyers, and baskets of fresh grapes ready to be loaded onto freight cars and shipped to cities like Chicago. A *North East Breeze* reporter noted that on October 18, 1902, he found "fifty large refrigerator cars being loaded with grapes." (North East Historical Society.)

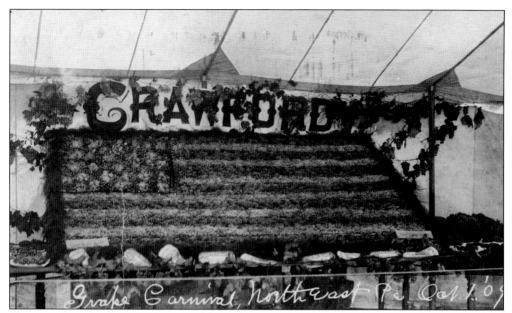

Here is a photograph-turned-postcard from the 1909 Grape Carnival in North East. There were local growers by the name of Crawford, and the Crawford Brothers were well-known grape shippers. One has to assume that the beautiful display of grapes was the work of someone from the same family. (North East Historical Society.)

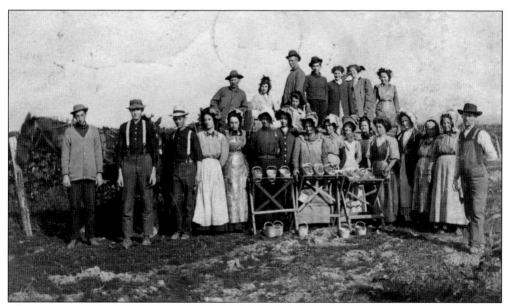

This image is on a postcard dated 1910. Oral histories and period photographs indicate that women and children played a very significant role as seasonal workers during harvest time. Although most grape pickers of the time were women, there were some men who helped with the harvest as well. (North East Historical Society.)

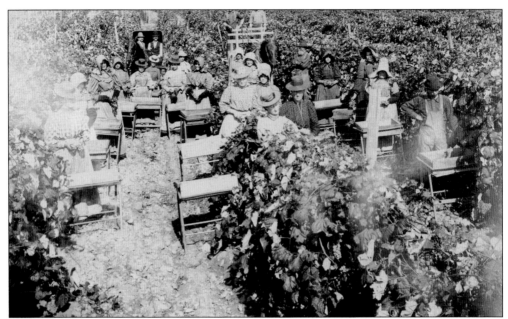

This photograph is said to be of "grape pickers on Walker Farm, South Cemetery Road." William and Francis Walker and their father built the world's largest grape juice plant in North East in 1909. The plant would be purchased from the bankruptcy court for $125,000 by Dr. Charles Welch. The two men in the buggy in the background appear to be men of authority, and they also resemble the Walkers. (Don and Jeff Buchholz Collection.)

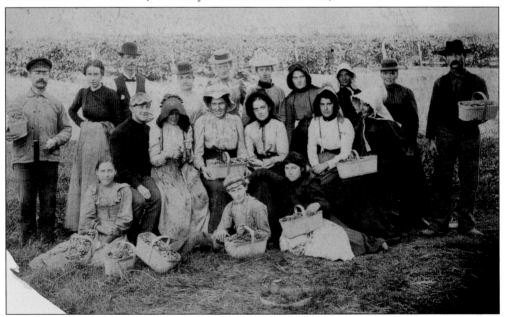

Harvest workers at Mottier Farm stop picking to pose for a photograph. John E. Mottier was known as "the Wine King of America" when he was hired by the South Shore Wine Company in 1866. He moved to North East from Cincinnati, Ohio, and worked as a winemaker for five years. Upon fulfilling his contract, he and his son established their own vineyards, farm, and winery. (North East Historical Society.)

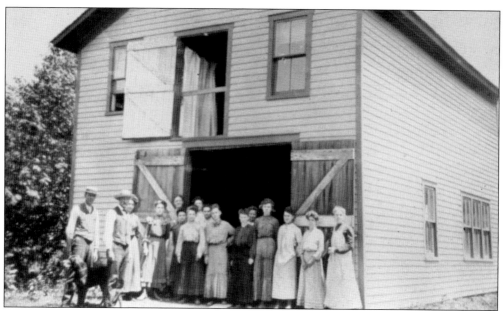

These undated photographs depict typical North East packinghouses in the early 20th century. Ralph Hartley, a local historian, wrote that "as early as 1898, hundreds of women and young girls came from all over the state to help pick fruit during harvests." Postcards written by grape workers show that they came from around the region, including the city of Erie and the Erie County towns of McKean, Waterford, Conneautville, and Conneaut, Ohio. Hartley reported that the number of females picking grapes in the vineyards likely exceeded 2,000. These women were often referred to as grape girls. The above photograph shows a packinghouse with workers' quarters upstairs at the Bostwick farm on Gulf Road in North East. (Both, Don and Jeff Buchholz Collection.)

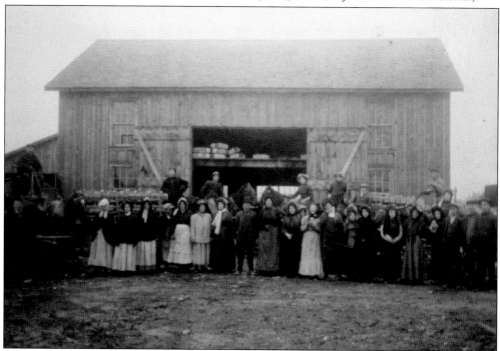

THIS IS THE KIND WE RAISE
IN NORTH EAST, PA.

By late 1893, North East was enjoying the fruits of their new industry. A correspondent of the time noted, "Never was there so much building and rebuilding and beautifying of private residences as at present." The pride was nicely depicted in this whimsical postcard from the early 1900s, and it continues to this day. (North East Historical Society.)

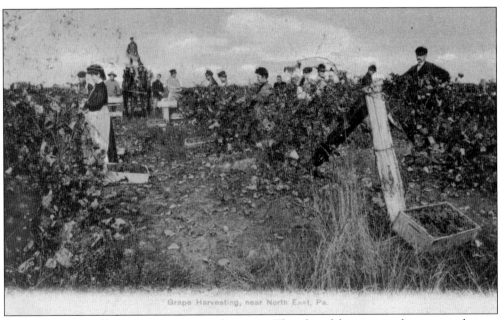

Some women viewed harvest season as a social occasion. They shared dormitory-style accommodations, and young single women could socialize with young men. Grower L.H. Youngs wrote that at times they "found it necessary to insist upon certain rules . . . There are always some among the girls who will keep late hours, and by disturbing the slumber of the tired ones put your whole force on the drydock for repairs the next day." (North East Historical Society.)

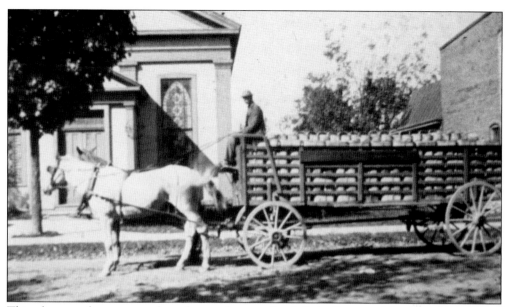

This photograph appears to have been taken on South Lake Street in North East in front of the Baptist Church of a shipment of full grape baskets heading toward the train station. The basket industry boomed during the heyday of grape shipping. In 1916, the Mottiers alone were manufacturing more than 500,000 baskets a year. (Don and Jeff Buchholz Collection.)

In this photograph, baskets of grapes are being loaded onto a refrigerator car for shipment to far away cities. A reporter from an earlier time wrote, "At the close of 1893, more than a million baskets of grapes were shipped at North East. That does not include those marketed in wagons." In 1895, approximately 450 train carloads of grapes were shipped from North East, amounting to 10.8 million pounds of grapes. (Don and Jeff Buchholz Collection.)

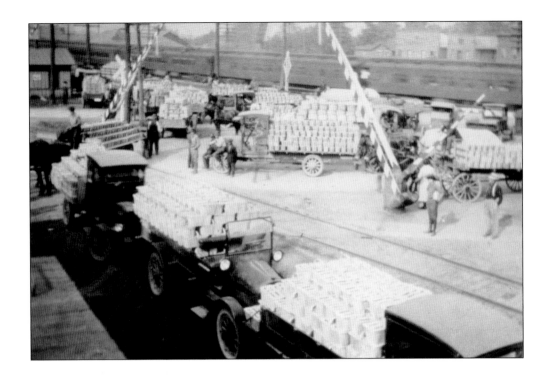

The North East train depot at South Pearl Street was a very busy place during the fall harvest. Major North East grape shippers included: Crawford Brothers, F.B. Moorhead, C.H. Mottier and Sons, and the Pierce Brothers, who were the second-largest fresh Concord shippers in North East Township in the early 1890s. The shipping label (below) appeared on baskets of grapes from the E.T. Moorhead Farm. (Above, Don and Jeff Buchholz Collection; below, North East Historical Society.)

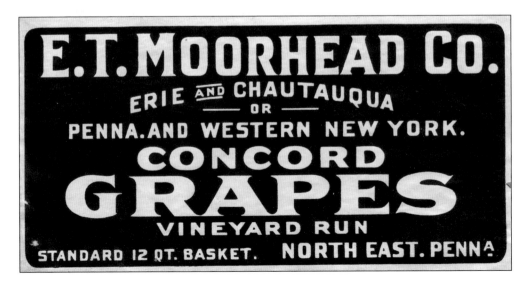

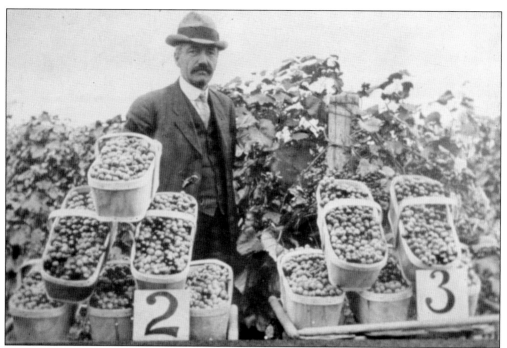

Very early on, growers experimented with ways to increase the yield of their crops. Demonstrating the positive effects of potash, this photograph was also used as a postcard and has a caption that reads, "F.B. Moorhead, Moorheadville, PA, Plot #2 with potash: 14,976 pounds of grapes. Plot #3 without potash, 12,432 pounds of grapes." (Don and Jeff Buchholz Collection.)

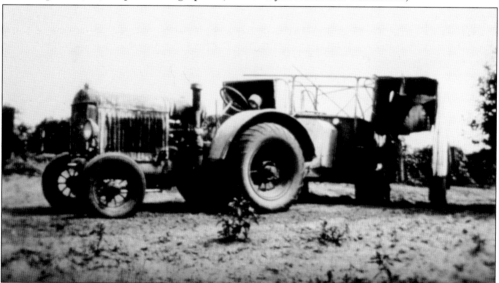

Growers also were very industrious when it came to applying chemicals that served as fertilizer, fungicide, or pesticides. This is an early two-row vineyard sprayer. The two tunnels were pulled by the tractor over the rows of grapes. The spraying took place inside the tunnel where there is no wind, so growers got better coverage and could spray on windy days. The sprayer used about 300 pounds of pressure, so there was a lot of activity going on inside the tunnels. (Don and Jeff Buchholz Collection.)

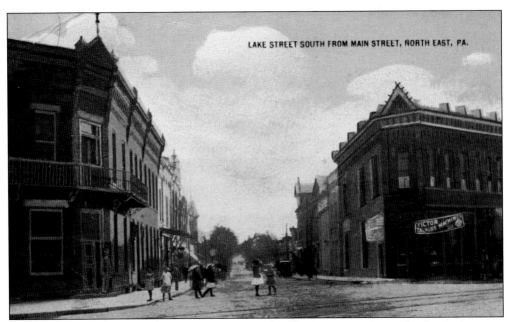

The town of North East, Pennsylvania, was incorporated in 1834. This is the downtown area from the corner of Main Street and looking southward on Lake Street in the early 1900s. In the lower right corner, trolley tracks that were introduced in 1901 are visible. Surrounded by grape vineyards, the town of North East is an important agricultural area, which still bustles with activity during every fall grape harvest. (Jim King Collection.)

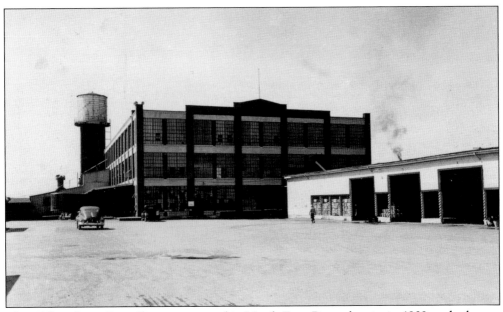

The Walker Grape Juice Company opened in North East, Pennsylvania, in 1909 as the largest grape juice manufacturing plant in the world. They went out of business quickly, and Dr. Charles Welch purchased the plant in 1911. This is the North East Welch plant as it looked in the late 1940s. (North East Historical Society.)

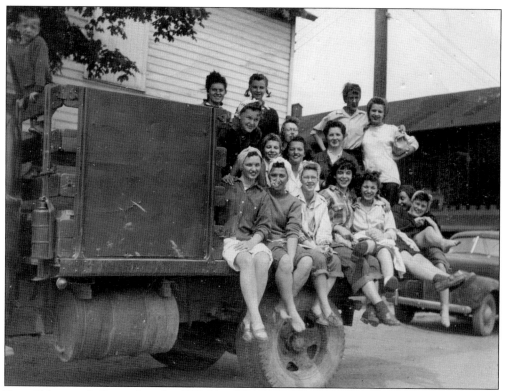

Beautiful young ladies gathered at Welch's in North East and climbed aboard trucks to be driven to nearby vineyards to pick grapes. The first girl on the top row is Marian Parmenter Tieber, who seemed older than her 11 years when she was first hired to pick grapes in the early 1940s. Young Marian picked grapes for Welch's every season throughout most of her teen years until she was old enough to be hired as a lab tech at the North East plant where she worked for nearly 20 years. (Anne Tieber Behling Collection.)

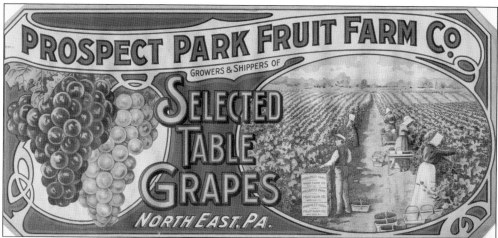

The Prospect Park Fruit Farm Company can be found in Erie County Directories of 1911 and 1916. R.H. MacBroom was the manager, and A.I. Loop was noted as the president. Loop was a wealthy North East entrepreneur who was invested in many enterprises. The company grew and shipped nearly 600 acres of various fruits, most of which were grapes. (North East Historical Society.)

This is the Mottier homestead on Middle Road in North East, Pennsylvania. John Mottier was the "Wine King of America," brought to North East to be the winemaker at South Shore Wine Company in the 1860s. Mottier and his son Charles created their own winery, grape farm, and basket company. The house and barn still stand on Middle Road near Orchard Beach Road. (North East Historical Society.)

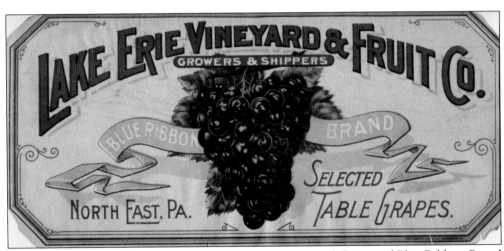

The Lake Erie Vineyard & Fruit Company was a grower and shipper of Blue Ribbon Brand Concord Grapes in North East, Pennsylvania. James Angus McDonald was the president and manager. Fred M. McDonald was secretary and treasurer. Fred was connected with the National Bank of North East and lived on the northwest corner of Gibson and North Pearl Street. (North East Historical Society.)

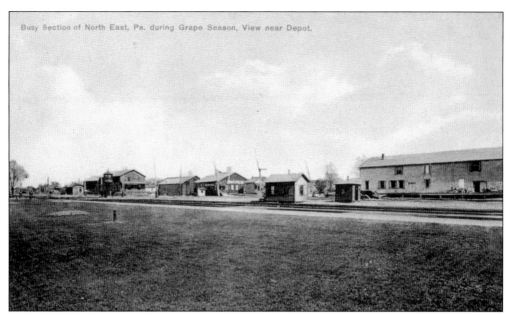

Busy Section of North East, Pa. during Grape Season, View near Depot.

This postcard from the early 1900s depicts the main railroad depot in North East on the Nickel Plate Railroad. The big building on the right is Mottier's grape-packing plant and basket factory. Also seen in the center of the photograph are other grape packing and shipping giants of the day, Moorhead Brothers and Crawford Brothers. The Keystone Grape Company is the first building to the right of the guard tower. (North East Historical Society.)

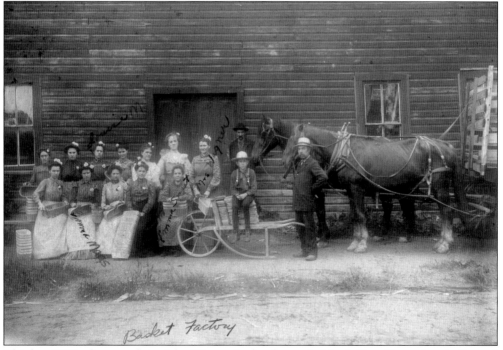

This late-1800s photograph is of the Wagner Basket factory in North East, Pennsylvania. Several basket makers made millions of baskets each year to provide to grape growers and shippers during the grape boom of the late 1800s to early 1900s. (North East Historical Society.)

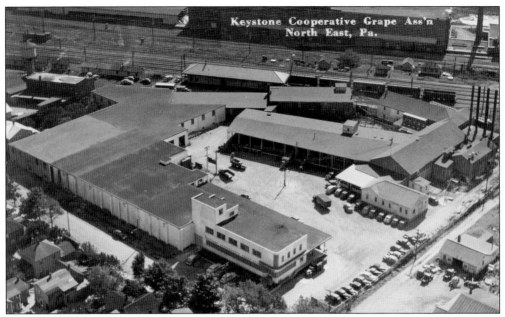

The Keystone Cooperative Grape Association was one of four in the region that decided to purchase a plant and produce grape juice for its members. The Keystone Association was incorporated in 1921 as a fresh-fruit shipper. In spring of 1938, they purchased the North East Preserving Works on Wall Street in North East, Pennsylvania. The plant is seen here in the 1940s. (North East Historical Society.)

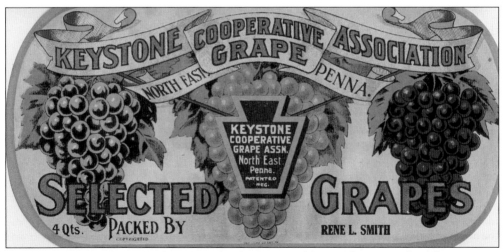

In 1938, Keystone's first year, they pressed only 50 tons of Concord grapes. The following year, they pressed 2,000 tons. In 1938, the co-op had about 168 members in their association. In 1943, they erected their first large cold-storage room where they could store up to 21,000 gallons of juice in wooden tanks. (North East Historical Society.)

Three

THE WELCH GRAPE JUICE COMPANY

A history of the Chautauqua-Lake Erie grape region cannot be told without turning much attention to the grape juice giant, Welch's. The Welch Grape Juice Company's decision to settle in Westfield, New York, in 1897 permanently changed the fabric of the region. The Welch story begins when Thomas Bramwell Welch and his family immigrated to the United States from England. Thomas was a Methodist pastor, an abolitionist, prohibitionist, medical doctor, and a dentist.

T.B. Welch moved to the "dry" community of Vineland, New Jersey, in 1868. Welch believed that alcoholic beverages should never be consumed, even as a church sacrament. His church officials gave him permission to find an alternative for wine. This was Welch's motivation for creating Dr. Welch's Unfermented Wine. It was in his home kitchen in 1869 that T.B. Welch and one of his sons, 17-year-old Charles Edgar, bottled 12 quarts of pasteurized juice. On that day, the grape juice industry was born, but it was Charles Edgar, also trained as a dentist, who grew the business, which he called C.E. Welch & Co. until it was incorporated in 1892.

There were not enough grapes in New Jersey to support the growing business, so Welch moved it to Watkins, New York, and—subsequently—to the attractive village of Westfield, New York. With its good schools, a hospital, many churches, and, of course, thousands of acres of delicious Concord grapes, it was the perfect place to expand the company.

The Welch Grape Juice Company went on to become successful beyond the imaginations of both Dr. Welchs. Dr. C.E. Welch passed away in 1926, and his sons sold the company to the Nashville Syndicate in 1928. In 1945, New York City resident Jack Kaplan purchased Welch's. Later, Kaplan himself facilitated a deal that allowed the farmer-owned National Grape Cooperative to become the owner of Welch's. It continues to operate the business, with the Welch Foods Company serving as the co-op's marketing subsidiary. More than 140 years after Thomas and Charles Welch cooked up their first dozen quarts of unfermented wine, Welch's Grape Juice remains a giant in the juice industry and is a household name in the United States.

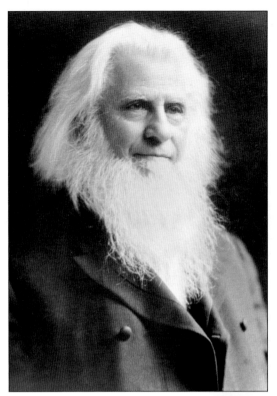

Thomas Bramwell Welch was born in Glastonbury, England, in 1825. He and his family immigrated to Watertown, New York, when he was in his teens. He was an abolitionist, a prohibitionist, and a preacher. He became a doctor in 1852 and a dentist in 1856. He moved to Vineland, New Jersey, and it was there, in his kitchen, where he first applied Louis Pasteur's methods to grape juice in an attempt to create a replacement for alcoholic communion wine. T.B. Welch conducted his grape juice experiments with the help of his third child, Charles Edgar Welch, who was then a teenager. (Welch Archives.)

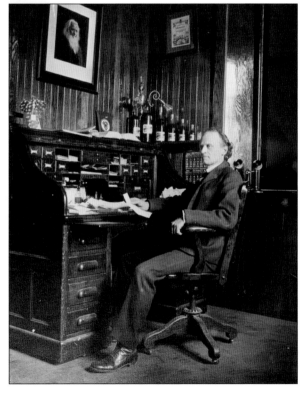

Charles Edgar Welch was born in Watertown, New York, in 1852. Like his father, with whom he was very close, Charles was religious. He later became a dentist. He married in 1879 and lived near Philadelphia where he opened the Welch Dental Supply Company. While his father became weary that the public was not taking to grape juice, Charles kept thinking about the prospects of a successful juice business. In 1893, he closed his dental practice to concentrate on grape juice. C.E. Welch is seen here in his Westfield, New York, office in 1904. Notice the portrait of his father on the wall and the bottles of grape juice on the shelf. (Welch Archives.)

Charles and Thomas Welch used the delicious Concord grape for their juice, which, in the early days, they called Dr. Welch's Unfermented Wine. When disease struck the New Jersey vines, they needed to find more grapes, so they moved their small factory to Watkins, New York. This proved a mistake, so they headed to the Chautauqua County, New York, Concord Grape Belt to seek out a new location. (Welch Archives.)

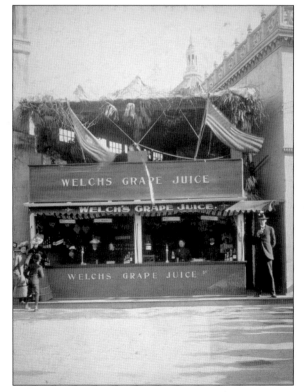

C.E. Welch knew that, in order to grow his business, he had to get his grape juice into the mouths of the public. In 1893, he was a vendor at the Chicago World's Fair where he served up grape juice to thousands of people from all over the world for 5¢ a glass. It was there that he began calling his unfermented wine grape juice. The exhibit was very successful. (Welch Archives.)

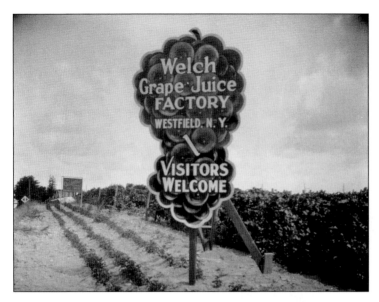

In July 1897, T.B. and C.E. Welch came upon the town of Westfield, New York, and immediately saw that it was the ideal location for their new grape juice factory. With thousands of acres of Concord grapes in the region, a hospital, good schools, electricity, a free library, charm, and a lot of churches, the Welchs prepared to settle in Westfield. (Welch Archives.)

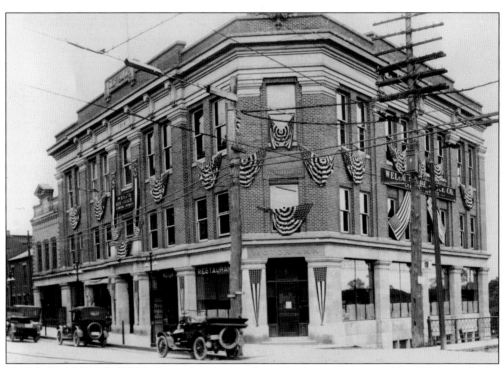

On July 28, 1897, C.E. Welch drove the corner stake at their new property at North Portage Street at the Nickel Plate Railroad. Their new factory was built on a 74-by-231-foot lot, which seemed ample at the time, but the Welch Company expanded rapidly. This photograph depicts the then extravagant $80,000 Welch Block, which C.E. built on his own in 1909 at South Portage and Main Streets. It provided office space for rent, four stores, and a restaurant. When the Welch Company needed more room to expand in 1921, they bought the Welch Block from C.E. and moved their offices into the corner building. (Patterson Library.)

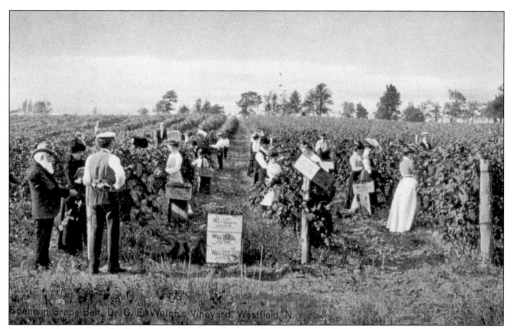

In this often-published photograph, Dr. T.B. Welch (with a white beard and a hat on the left) and C.E. Welch (wearing a hat with his back to the camera) pose with carefully staged grape pickers and Welch crates during the harvest of 1902. Welch's demanded only the finest fruit for their products. (Welch Archives.)

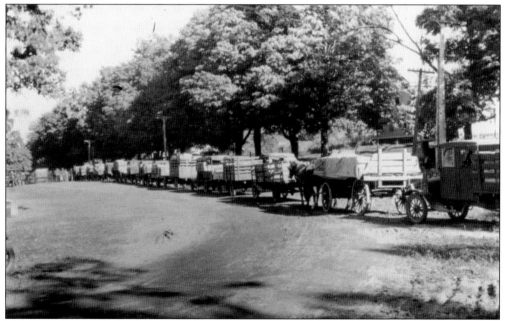

This photograph, taken around 1920, shows how horse-drawn carts and the occasional farm truck made their way to the Welch plant each autumn to deliver the year's harvest. In the first year of operations in Westfield (1897), Welch's paid $10 for each ton of grapes delivered. In 1903, they paid $20 per ton. There were some fluctuations in price, but—overall—the level grew steadily. In 1917, farmers earned $60 per ton, and in 1920, they were paid $130. (Welch Archives.)

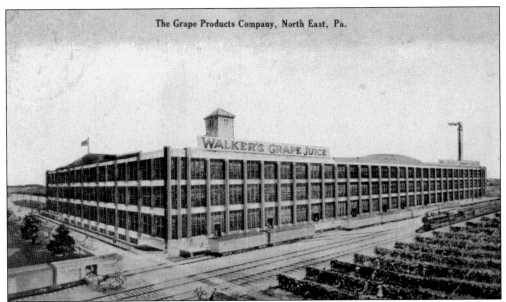

The Grape Products Company, North East, Pa.

In 1907, William Walker, with help from his father, Francis, purchased a small grape juice plant in Fredonia, New York. Excited about the prospect of juice manufacturing on a big scale, and considering the huge gorge that often prevented farmers in the western part of the grape belt from delivering their grapes to Westfield, the Walkers spent $230,000 to build in North East, Pennsylvania, what was undoubtedly the world's biggest juice plant. They immediately ran into financial difficulty, and in 1911, the Welch Company, which was ready to expand yet again, jumped on the opportunity and purchased the state-of-the-art plant for a mere $125,000. If one looks at these two postcards, one will notice that the new Welch management made good use of the old Walker plant drawings, simply converting them into new Welch postcards. (Both, North East Historical Society.)

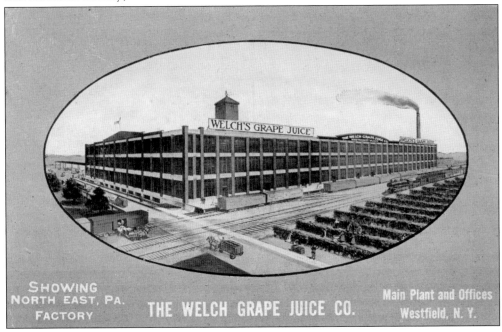

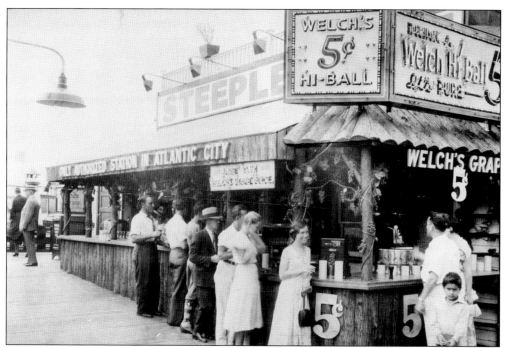

The reasons for the tremendous success of Welch's are numerous, but chief among them is the mastery Charles Welch had in advertising and promoting his product. He actively sought out venues that attracted huge crowds. This 1922 photograph shows the permanent Welch's stand on the Atlantic City Boardwalk. Thousands of vacationers each year were introduced to Welch's Grape Juice for just 5¢ a glass. (Welch Archives.)

Early on, Charles Welch understood the power of advertising and of the written word. In 1875, he began publishing a pamphlet called *The Acorn*. In it, he espoused the virtues of drinking unfermented wine, and he placed advertisements "for the sacrament and medicinal use." He continued printing his own publications in Westfield, New York. Shown here is a 1914 Welch magazine cover. It was C E. Welch himself who dubbed Welch's Grape Juice as "The National Drink." (Welch Archives.)

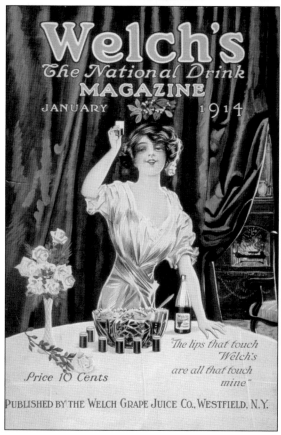

A pioneer for modern advertising practices, C.E. Welch spent millions of dollars on advertising and promotions when it was still unheard of. He wrote, "Advertising has played a major part in the development of our market, and I cannot overemphasize its importance to a business which seeks national distribution and large volume." In 1921, Welch's spent $376,000 on advertising. From 1912 to 1926, the company spent an average of $575,000 annually on marketing. (Welch Archives.)

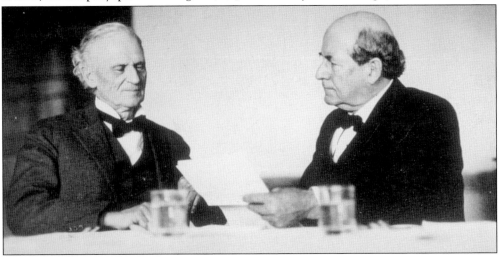

Another event that led to the rise of the Welch name occurred in 1913 when Secretary of State William Jennings Bryan asked guests at an important state dinner to "omit wines." He instead served Welch's Grape Juice. The ensuing media frenzy provided plenty of free advertising for the Welch brand. Dr. Welch is shown here with Secretary Bryan, a fellow teetotaler. Furthermore, in 1914, Secretary of the Navy Josephus Daniels replaced alcoholic beverages on all naval ships and naval yards with Welch's juice. This had the same effect. Welch's was becoming a household name. (Welch Archives.)

Dr. Charles Welch was an innovative thinker, always looking for new ventures. He invested in real estate, drilled for and sold natural gas, and even planned to open a health spa. This was halted when he had to spend the capital for the North East plant. In 1920, C.E. got involved with the Thomas Coupling Corp. and eventually bought control. He changed the name to Ajax Flexible Coupling. His son purchased the company after C.E.'s death, and when it was sold again in 1972, it became the Renold Corporation, which still exists. (Patterson Library.)

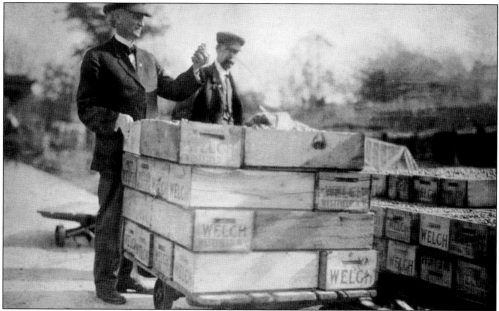

Dr. Welch is seen in this undated photograph inspecting a recent delivery of grapes. He actively oversaw his juice business and his other businesses, but he still found time to serve his community. He was the superintendent of his Sunday school for 25 years, he served as mayor of Westfield from 1916 to 1919, and the Prohibitionist Party nominated him for governor of New York. They were beaten, but then it was only 1916. They would soon overcome. (Welch Archives.)

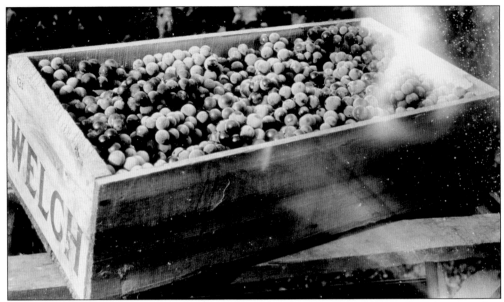

In 1921, Dr. Welch published a small book called *Juice as a Therapeutic Agent*. In it, he prescribes grape juice "as a beverage in health, during fevers, convalescence, after operation . . . and in debilitated states. As an adjuvant in the treatment of constipation, abdominal plethora . . . renal congestion, edema, cardiac disease . . . As a tonic and appetizer." Welch offered free juice to physicians who wished to conduct clinical tests with the product. The key, of course, was the Concord grape. (Welch Archives.)

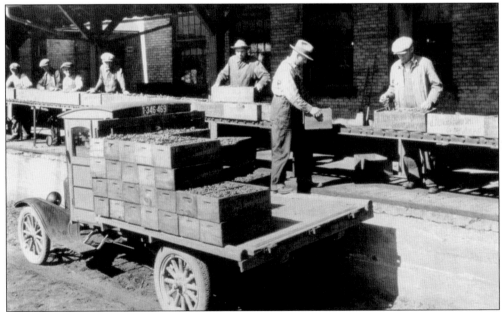

In this photograph from the early 1900s, Welch workers inspect grapes that have just been delivered as they dump them onto a conveyor to send up to the processing area. In Dr. Welch's book *Juice as a Therapeutic Agent*, he explains that the wooden Welch crates were "of limited size to prevent crushing or heating . . . At the plants they are inspected and weighed, and washed as they are conveyed to the stemming machines." (Welch Archives.)

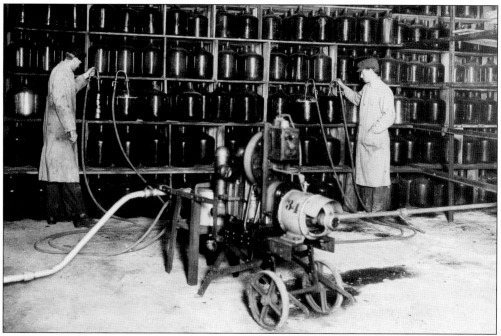

According to Dr. Welch's book, after grapes were removed from the stems, they were heated and pressed. The juice was then heated just sufficiently enough to prevent fermentation, and then it was pumped into glass carboys, shown in this undated photograph. The juice remained in the carboys for several months to permit the argols, or crude cream of tartar, to settle. (Jim King Collection.)

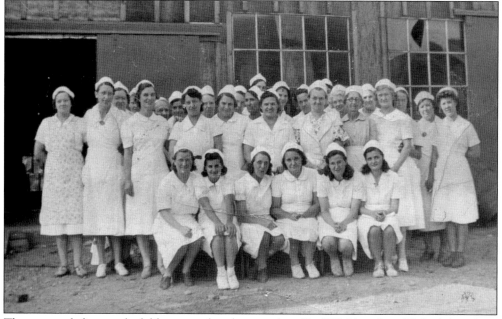

These young ladies may look like nurses, but they were hired by Welch's to show TLC while picking premium Concord grapes. Known as the Welch Girls, they stopped to pose for the photograph before heading to a harvest in the late 1930s in North East. The second girl in the front row is Dorothy Hautzinger Parmenter. (Anne Tieber Behling Collection.)

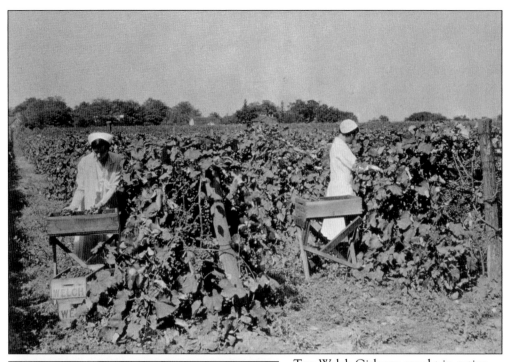

Two Welch Girls are caught in action during the annual grape harvest. This photograph was probably taken in the early 1930s. (Welch Archives.)

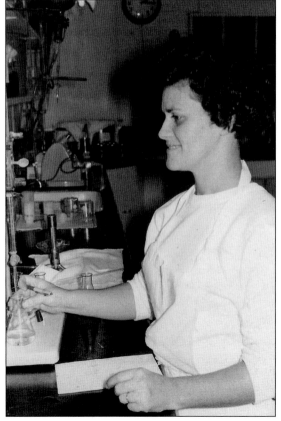

The Welch Company continually experimented with ways to make its products better and its processes more efficient. Marian Parmenter Tieber, pictured here, worked in the Welch lab at the North East plant for nearly 20 years. She loved her job and was sent to Cornell for continuing education instruction. (Anne Behling Collection.)

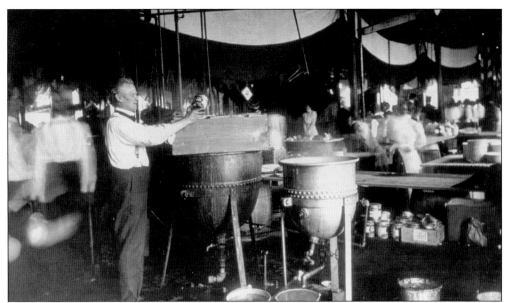

The date and location of this photograph are unknown, but it is included because it is interesting. It appears to be an event of some kind. Several busy figures glided through the exposure leaving ghostly imprints behind. Dr. Charles E. Welch is shown holding a can of coffee. There are big boilers, several cans of coffee on a low shelf, and buckets of fresh water. Judging by the color of C.E.'s hair, it was likely taken in the early 1900s, and it appears the CEO of a successful corporation was ironically in charge of making the coffee. (Welch Archives.)

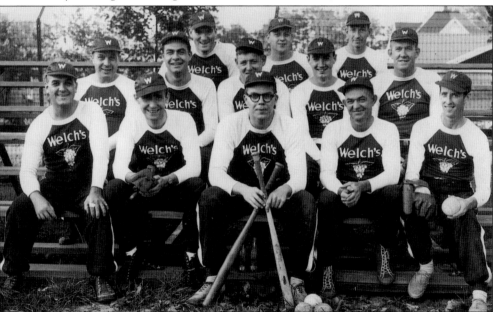

The Welch Company promoted hard work but also good core values and healthy fun. This company softball team looks happy for the opportunity to pose for this undated photograph. (There may be Coca Cola bottles between the bats.) Charles purchased property to create Welch Field at the corner of Union and Third Streets in Westfield. Charles and his son Edgar deeded five acres in the corner of the field to the YMCA to use as an athletic area. (Patterson Library.)

Welch's even sponsored a beauty pageant at its North East, Pennsylvania, facility. Taken in the early 1950s, this group of ladies posed with the newly crowned Miss Welch's. It looks like she won a huge bunch of grapes. The last lady on the right is Marian Parmenter Tieber. (Anne Tieber Behling.)

Under the leadership of Dr. C.E. Welch, Welch's grape products became known all over the world. Between 1897 and 1922, Welch had paid local grape growers over $7 million, resulting in significant economic impact. He was also a philanthropist, donating thousands of dollars to the local hospital, his church, and several other causes. (Welch Archives.)

Charles and Julia Welch had a home in St. Petersburg, Florida, to escape the long northwestern New York winters. In the winter of 1926, Charles made his last trip to his vacation home. On January 6, he suffered a heart attack and passed away. He was 73. Dr. Welch is buried in the Westfield Cemetery, not far from his home and his beloved church. (Patterson Library.)

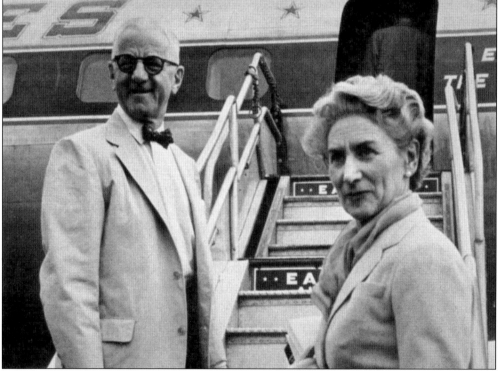

Following C.E. Welch's death, his sons ran the company for the next two years before selling it in 1928 to an investment group called the Nashville Syndicate. The company held on to Welch's until 1945 when they sold it to Jacob "Jack" Merrill Kaplan, who had successfully run the National Grape Corporation (formerly the C&E Grape Products Company) in Brocton from 1933 until 1945. He is seen here with his wife. Kaplan revitalized Welch's and actually facilitated its sale in 1956 to the National Grape Cooperative Association. (Welch Archives.)

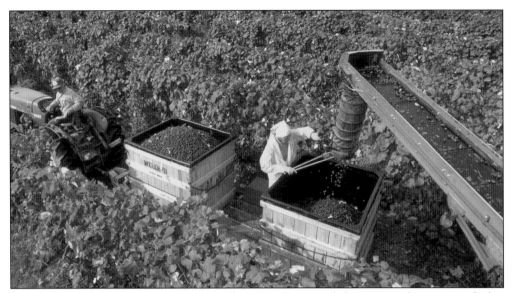

Jack Kaplan is credited by many as being the man who turned the grape industry around after purchasing the Welch Company in 1945. That year, he met with grape growers. He was earning 25¢ per case of grape juice. He offered to set these profits into a separate fund and let the money accumulate. When the sum reached $2 million, he would transfer the ownership of the plant to the National Grape Cooperative. This happened in 1956. Kaplan truly respected the growers and desired a close working relationship with them. Under Kaplan, growers prospered. (Welch Archives.)

Because of its proliferation of new products, such as jellies, jams, Grapelade, and fruit juices, the Welch Grape Juice Company changed its name to Welch Foods, Inc. (Welch Archives.)

Four

EVOLUTION OF THE GRAPE PICKER

Grapes have been cultivated for more than 8,000 years, and for most of those years, they were harvested by human hands. Early grape pickers in the Lake Erie Wine Country region were usually overdressed women and children who were well-suited for the repetitive work. Local historian Ralph Hartley wrote that as early as 1898, hundreds of local women and young girls came from all over the state to help pick fruit during harvests. These early pickers were often called "grape girls." He reported that during harvest time, more than 2,000 females could be counted in the vineyards.

People fueled the grape harvest for decades, but following World War II and then the Korean War there was a general farm labor shortage. Migrant farm workers from Mexico and Puerto Rico were brought to the region to help with grape harvests beginning in the 1950s. Growers had to convert packinghouses into dormitories and find other lodging for their seasonal helpers. The agricultural economy was changing; labor costs were going up and grape prices were coming down.

In 1959, Roy Orton, a recent Cornell graduate, purchased his first Concord grape farm in Ripley, New York. After only a few tedious harvests, he sought a solution to the hand-harvesting issue. He noted the successful harvest of his father's cherry trees by shaking the limbs with a mechanical arm attached to a tractor. He and his uncle Max Orton wondered if they could apply the same idea to harvesting grapes. For the next four years, the Orton's conducted a series of hit-or-miss experiments to design an effective mechanical grape picker.

Although they kept the invention somewhat quiet, the Chisholm-Ryder company of Niagara Falls found out about it and contacted them in 1967, offering to build two units and test them. The mechanical harvester was a great success. The first units were sold in 1968. Orton's invention revolutionized—and some would say revitalized—the grape industry in the region. Harvest costs dropped dramatically, and profits surged. Today, several companies sell mechanical harvesters, but they all use the concept once dreamed up by Roy and Max Orton of Chautauqua County, New York.

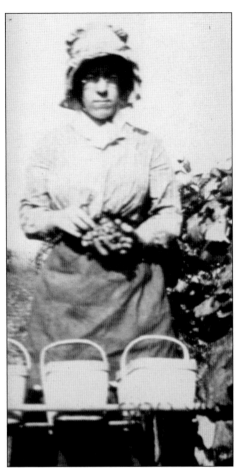

Primary and secondary sources (including oral histories and photographs) indicate that women and children played a very significant role as seasonal workers during harvest time. Around the turn of the 20th century, this woman was employed to harvest and pack grapes into four-quart wooden baskets. Heavy bonnets and long dresses were the common packing "uniform" of the day. (Don and Jeff Buchholz Collection.)

This harvest photograph was printed as a postcard that reads, "Vineyard scene, North East, Pa." The town of North East, with thousands of acres of grapes, was determined to name its school mascot the North East Grape Pickers early in the 20th century. Apparently, those who picked the mascot name did not foresee the competitive nature of future school sports. The name stuck, and "Pickers" are proud of their grape heritage. (North East Historical Society.)

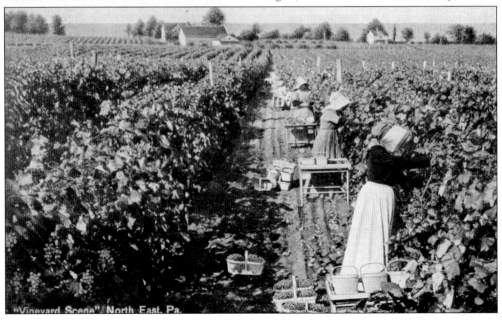

"Vineyard Scene", North East, Pa.

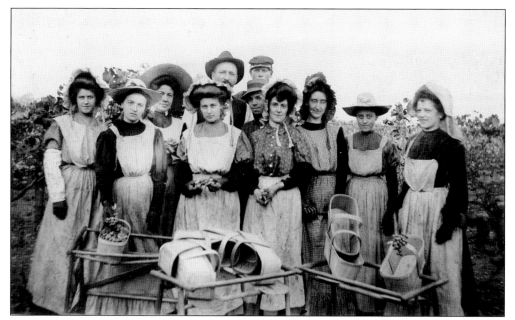

An early 20th-century postcard written from North East reads: "Dear Miss R. I am having a dandee time, Clara." An observer wrote at the time: "Girls in their teens, rosy-cheeked maidens, and gray-haired mothers, flock to the vineyards from the neighboring farms and villages." The hard work in the grape belt allowed women the opportunity to earn income during a period when there were few options for them. (Moorhead Farms.)

Tractors were introduced to grape farming in the early 20th century and growers utilized them to help speed up the harvest. Plastic yellow crates for the harvest were introduced in the late 1950s. These crates were filled by human grape pickers and left for the tractor to come along and pick them up. (Don and Jeff Buchholz Collection.)

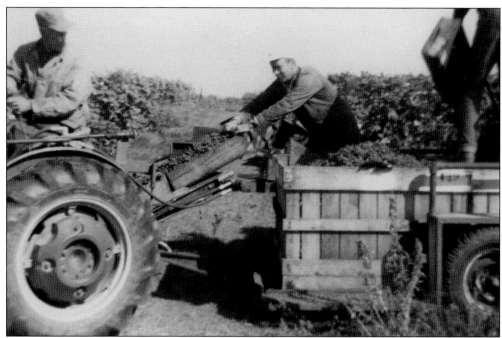

It was left to the growers to figure out how to save time and make their picking operations more efficient. In the 1960s, before the mechanical harvester, John Moorhead devised this clever system to streamline the harvest. A conveyor belt ran from the side of the tractor up to the trailer, which pulled a large wooden box. Someone rode on the trailer and gently emptied the grapes into the bins. (Moorhead Farms.)

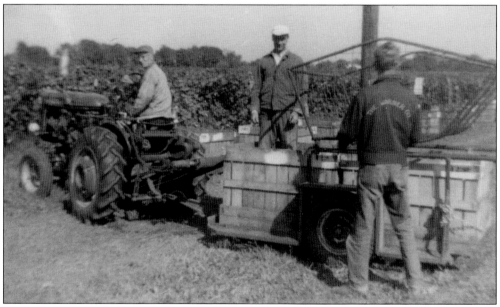

This photograph, taken at Moorhead Farms in Harborcreek, Pennsylvania, in 1968, shows another clever invention by John Moorhead. He built a metal cage that sat on top of the grape bins that were pulled by the tractor for grape collection. Once the small crates of grapes were dumped into the large bin, the cage held the empty crates. (Moorhead Farms.)

Roy Orton was only 20 years old when he purchased a 24-acre Concord grape farm in Ripley, New York. By the time he was 26, he and his uncle Max had developed and patented a design for a single-trellis, over-the-row mechanical grape harvester. In this photograph from the mid-1960s, Orton is tying dormant grapes on a winter day. (Patterson Library.)

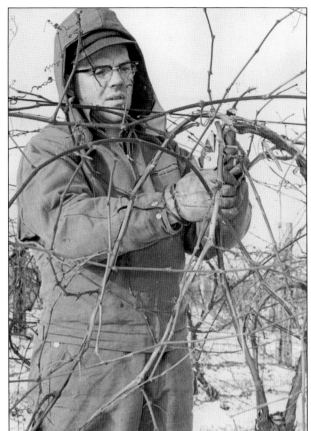

Necessity is the mother of invention, and at a time when labor was problematic, Roy and Max Orton were determined to create a mechanical grape harvester. They worked on the prototype from 1963 to 1967, initially using scrap metal, plywood, and tree branches in various widths and lengths. Roy Orton is seen here in 1967 with his new invention that would revolutionize the grape industry worldwide. (Don and Jeff Buchholz Collection.)

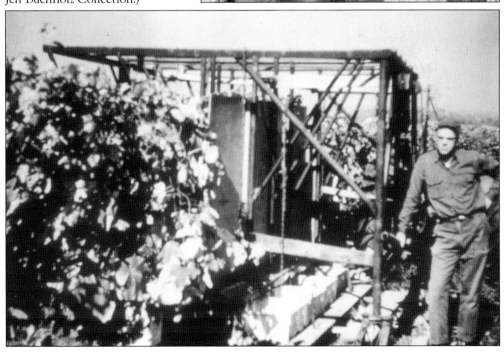

Roy and Max Orton's over-the-row design was for a single-trellis growing system. The framework was designed to cover the top and sides of each grape row. It was pulled by a tractor, and the tractor's crank shaft caused action that moved "fingers," which dragged through the vines, shaking off the ripe fruit. The grapes were caught on a conveyor and dropped into crates. (Don and Jeff Buchholz Collection.)

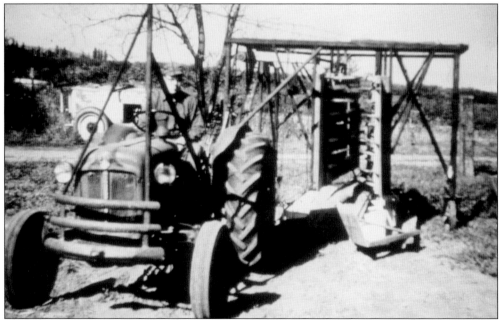

When the Chisholm Ryder Company of Niagara Falls heard about Roy Orton's prototype harvester, they paid him a visit. It was winter, and the grapes had already been harvested, but Orton demonstrated anyway. They liked what they saw and used Orton's patented design to build the first harvesters. In 1968, those harvesters were on the market and became the most widely used single-trellis pickers in the world. (Don and Jeff Buchholz Collection.)

The Chisholm Ryder Company made an agreement with Roy and Max Orton to initially build two pickers—a pull-behind model and a self-contained model. This is the pull-behind prototype that was built in 1967. A handwritten caption on the back of the photograph reads: "The early ones had troubles." Roy Orton tested both pickers, and he decided the self-contained model was superior. Their pull-behind idea was scrapped. (Patterson Library.)

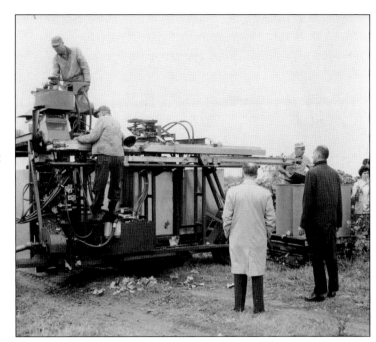

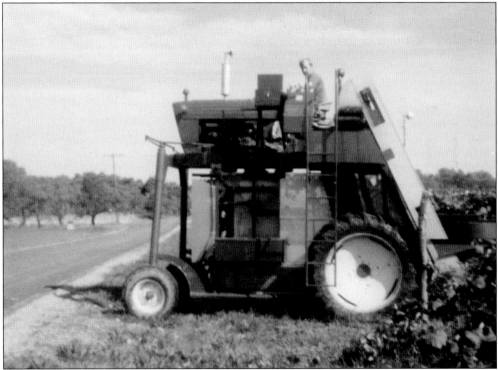

When Roy Orton originally designed his mechanical harvester, he thought the pull-behind picker made the most sense for farmers who already had tractors. But when the Chisholm Ryder Company flew him to California to test the first self-propelled harvester prototype, he was sold. The self-propelled model went on the market in 1968. This harvester was purchased by Moorhead Farms in Harborcreek in 1970. (Moorhead Farms.)

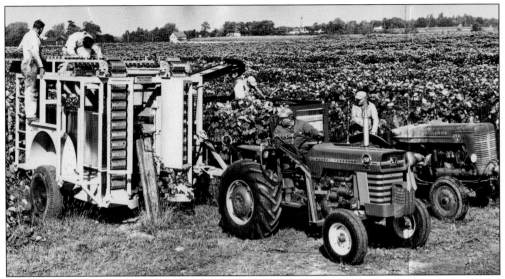

While Roy and Max Orton were developing their single-trellis picker in Ripley, New York, developers at Cornell were working on a double-curtain-style grape picker. About the same time, Vito Mecca, a John Deere dealer and grape grower in North Collins, New York, designed this "Mecca-Nized" pull-behind mechanical harvester. This harvester worked on the same principal as the other models, with paddles that knocked the ripe grapes off the vines. It required a (minimum) 50-horsepower tractor to pull it and, with only two wheels, was relatively easy to turn. There is controversy about who actually designed and patented the first harvester. Because of this, Vito Mecca did not receive his patent until 1988, one year after his death. The Mecca harvester sold about 300 units between 1968 and 1978. A few are still in use in the region. (Both, Patterson Library.)

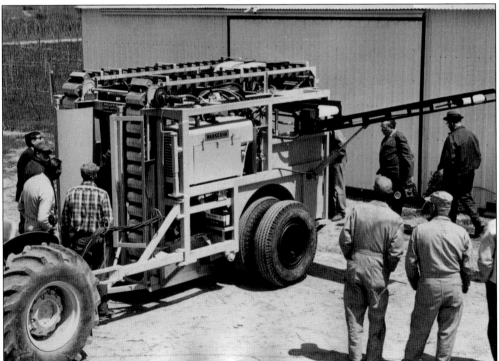

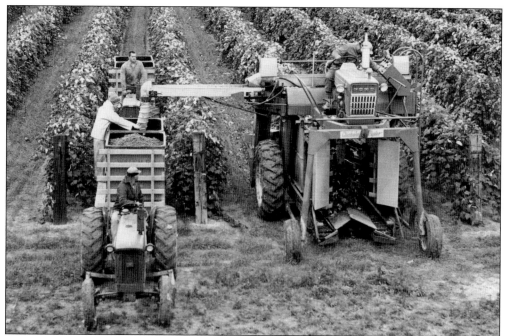

This photograph from the 1970 harvest shows how a modern mechanical harvest works. The harvester straddles a row of grapes, and as it moves along, plastic paddles knock the ripe fruit off the vine. Grapes are collected on a conveyor that moves them to the back of the picker then up to a conveyor on a boom that reaches into the next row where a tractor pulls empty bins. The grapes fall into the bin. When the bins on one trailer are full, another tractor with empty bins takes its place. (Patterson Library.)

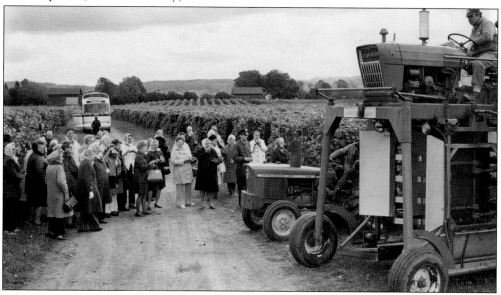

Grape harvesters have been tourist attractions since the beginning, and they still are today. In this October 1972 photograph, a senior citizens group from Warren, Ohio, is getting a tour of Steven Baran's vineyards and getting an up-close look at the new mechanical harvester. (Patterson Library.)

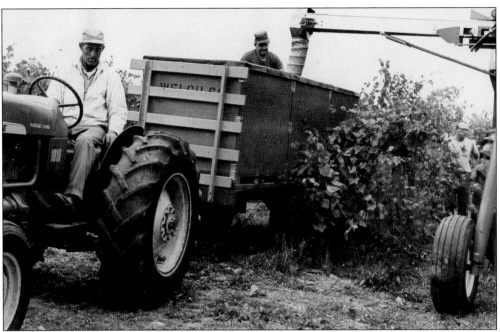

Grapes have been grown on the Nixon Brothers Farm in Westfield since 1868. They grow native varieties, including Concord, Catawba, and Niagara. Here they are using a mechanical harvester in the early 1970s. On the tractor is Larry Dalton, loading is Henry Gibson, and standing is George Abbey. (Patterson Library.)

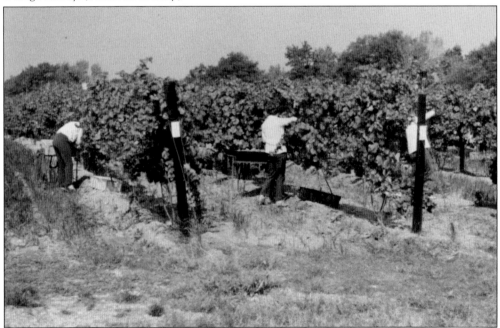

These grape pickers are handpicking grapes at Moorhead Farms in 1973. Not all grapes could be mechanically harvested. Delicate wine grapes, such as Gruner, Merlot, Riesling, and Cabernet Sauvignon, are often still handpicked. Moorhead Farms now has a specialty grape picker that they use on wine grapes, which has proven to be more delicate than handpicking. (Moorhead Farms.)

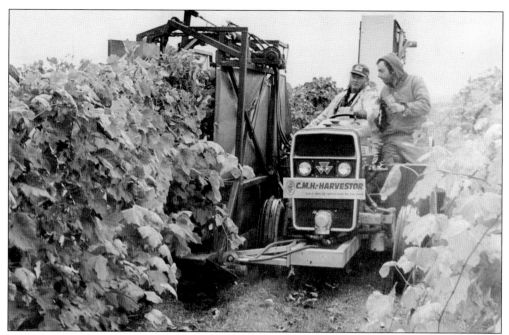

In 1976, a North East grape grower named Pete Clark designed and built this pull-along harvester meant to help with small vineyards of 40–50 acres. He is seen here with Nick Mobilia of Mobilia Fruit Farms. Nick was filming Clark's invention so they could market the small harvester. Clark sold several dozen locally and in other countries, including France. (Patterson Library.)

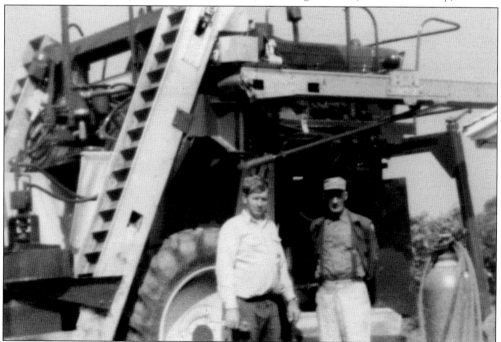

John Moorhead (left) of Moorhead Farms poses with his new 1979 mechanical harvester. Harvesting grapes has remained pretty much the same since Roy and Max Orton's successful design went into production in 1967. (Moorhead Farms.)

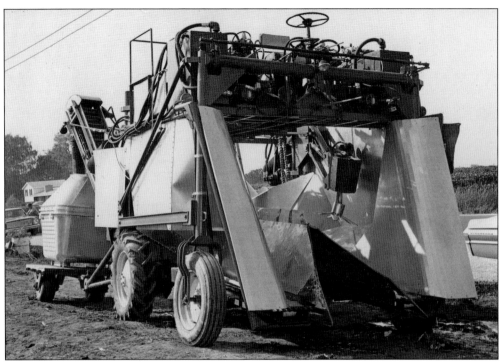

This is a very early mechanical harvester tested by the Welch Grape Juice Company in October 1965. (Patterson Library.)

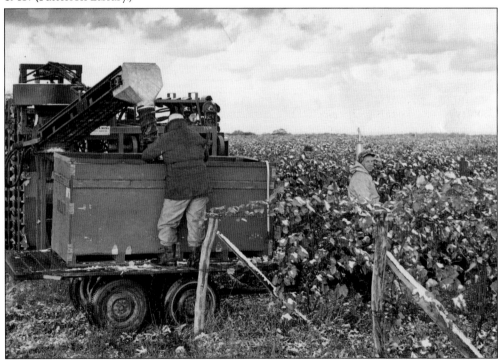

In October 1972, the first snow of the season fell during harvest time. Notice the pull-behind mechanical harvester. Driving the tractor is A. Portman. (Patterson Library.)

Five

GRAPE FARMS ENTER THE WINE BUSINESS

The Lake Erie Wine Country region is known to be a perfect setting for fruit and vegetable farms. The well-drained soils and Lake Erie breezes create a terroir conducive for growing high-quality fruit. Several of the region's wineries were established on fruit farms that had been around for generations. There are also several farms that once grew only Concord grapes for juice that now grow only wine grapes, as in the case of the John Moorhead farm in Harborcreek, Pennsylvania. John never wanted to open a winery, but as a challenge in 1967, he planted several hybrid wine varieties, including Seyval, Chelois, and Aurore. He also added vinifera varieties, such as Chardonnay and Riesling.

By the late 1800s, there were about 30,000 acres of grapes being farmed in the Lake Erie Wine Country region. That is pretty much the same acreage there is today. Most of those grapes were originally Concord grapes grown for grape juice and jellies. As the decades went by, however, growers who wished to expand and diversify realized that it would be very beneficial to grow wine grapes.

In 1970, a study of the Pennsylvania grape vineyards revealed that there were about a thousand acres of native wine varieties, such as Niagara, Delaware, and Catawba. They also accounted for 200 acres of various French hybrid varieties and 25 acres of vinifera. The earliest wine grape growers in the region were those growers who opened the first wineries: Douglas P. Moorhead Jr., who owned Presque Isle Wine Cellars, and the three growers who opened Penn Shore Vineyards—P. Blair McCord, George F. Luke, and George W. Sceiford. Joseph Mazza, who had grown grapes in his native Italy, settled in North East in 1961, and he and his sons Frank and Robert established and managed 18 acres of grapes. Frank and Robert went on to start Mazza Vineyards in 1973.

It is a misconception that the Lake Erie Wine Country region grows only Concord grapes. Although the growers and winery owners are proud of their Concord heritage, they have evolved over time and are now growing significant amounts of wine grapes for use in their wineries.

There is a large area between North East and Harborcreek, Pennsylvania, known as Moorheadville, named for the original family that moved there from Lancaster County, Pennsylvania, around 1811 and purchased 1,000 acres. The man is this photograph, taken about 1905, is Cal Leet. Leet and his wife, Edith Moorhead, built the home on Route 20 in Harborcreek that now belongs to John and Cindy Moorhead. (Moorhead Farms.)

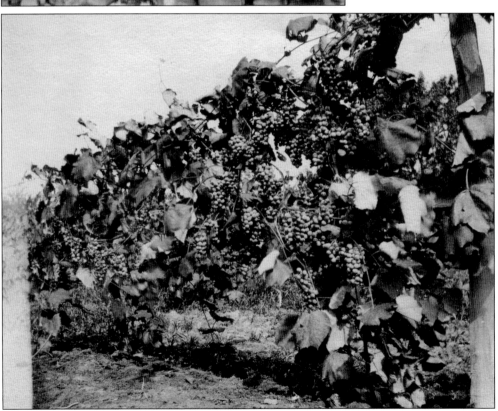

Victor Moorhead owned a large farm in the Moorheadville area. At that time, the majority of grapevines were Concords. This 1911 photograph shows the healthy Concords grown on his farm, which was located near the Moorheadville Airport. (Moorhead Farms.)

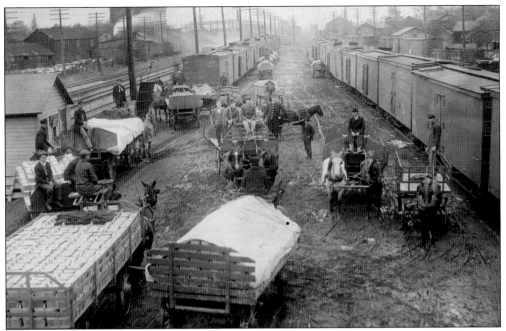

In the 1870s, shipping of table grapes to cities far and wide became very profitable for local growers. This is the busy train depot in North East, Pennsylvania. The caption on the original photograph says, "E.J. Moorhead, Produce Shipper." Moorhead was one of the major shippers at the time. (Moorhead Farms.)

This undated photograph shows one of many vineyards of the J.M. Moorhead farm. In the distance is a peach orchard. Moorhead Farms was mainly a Concord-growing operation for many years until John Moorhead began planting wine varieties in 1967. Today, the Moorheads grow 25 different varieties of wine grapes, including some French hybrids and vinifera, plus a number of table grapes. (Moorhead Farms.)

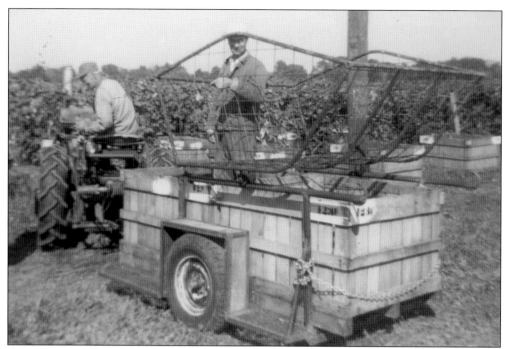

Before mechanical harvesters were invented, John Moorhead built this "cage" and put it over his grape collection bins to hold the yellow plastic grape crates after they were emptied into the bins. This photograph was taken during the grape harvest of 1968. (Moorhead Farms.)

Children born into grape-growing families are often expected to start working at an early age. This is a 1973 photograph of Michael Moorhead harvesting grapes, or perhaps he is just sampling them. Michael would graduate from Harborcreek High School, get his degree in film production, and spend 12 years in Los Angeles and Las Vegas before returning to the family farm. (Moorhead Farms.)

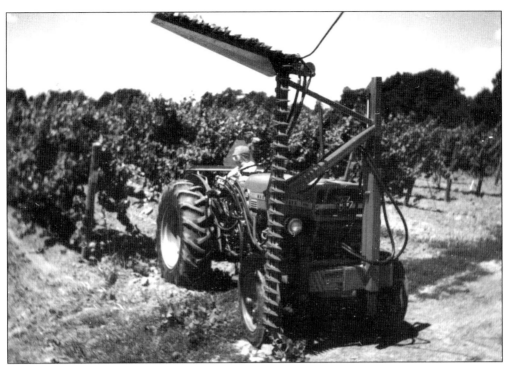

This 1973 photograph is of a clipper bar attached to a tractor. This clipper bar removes the excess green foliage on the trellis over the summer months to expose the grapes to more sunlight and thus better ripening. The toddler on the tractor is grower Mike Moorhead. (Moorhead Farms.)

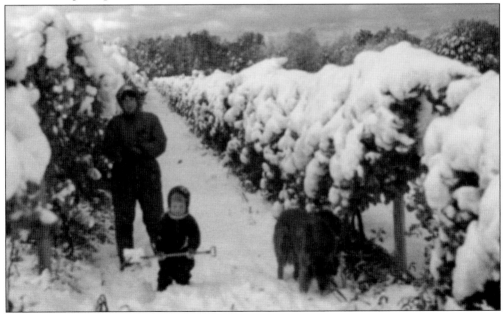

In 1973, a freak snowstorm hit while the Riesling vines were still laden with grapes ready to be picked. Because the snow insulated them, there was no damage to the grapes. Cindy Moorhead of Moorhead Farms in Harborcreek is seen here with her dog Cognac and her son Michael, who now works with his parents in the vineyards. (Moorhead Farms.)

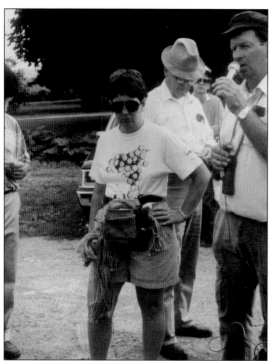

Some grape growers are happy to educate people about their interesting industry. Cindy Moorhead of Moorhead Farms displays her grape-tying gear around the 1970s during a visit from a Canadian bus tour group. String for the vines, clippers, and work gloves are part of the grape-tying uniform. (Moorhead Farms.)

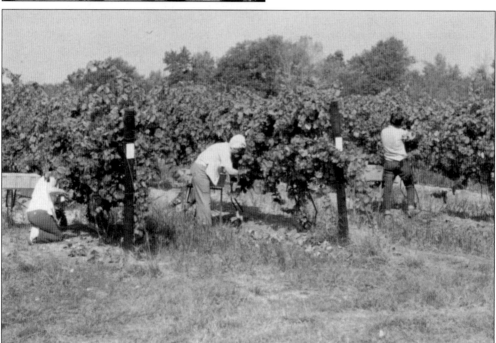

Grape pickers work hard in the Moorhead Farms vineyard during the harvest of 1973. The Moorheads had a mechanical picker as of 1970, but they still picked certain varieties of wine grapes by hand until the purchase of the Upright Harvester in 1990. This machine handled the fresh grapes as gently as the hand pickers did. It was quite a revolution in the area to be able to machine harvest and not be dependent on the weather. (Moorhead Farms.)

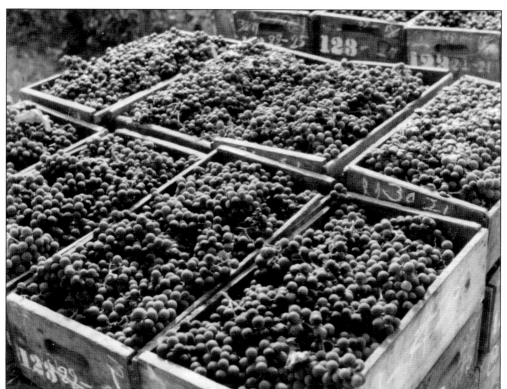

These are delicious and healthy Concord grapes picked in 1968. It was in the mid-1960s when, with the encouragement of Douglas Moorhead and Dr. Konstantin Frank, John Moorhead decided to tear out most of his Concord vines to plant wine varieties. Today, Moorhead farms grows about 25 different varieties including 10 vinifera, 7 hybrids, 3 French hybrids, 3 Labrusca, and 15 varieties of table grapes, including PieBlu, a delicious hybrid used in pies and pastries. (Moorhead Farms.)

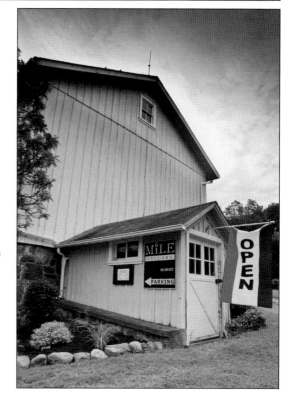

The first winery in Harborcreek, Pennsylvania, was 6 Mile Cellars. Friends Barton Towell and Patrick Walsh opened the winery in May 2012 on the corner of Clark and Firman Roads, just yards from 6 Mile Creek. The winery's unique tasting room is part of an authentic, well-preserved 100-plus-year-old horse barn. The winery successfully blends the farm's rich history with creative modern accents. (6 Mile Cellars.)

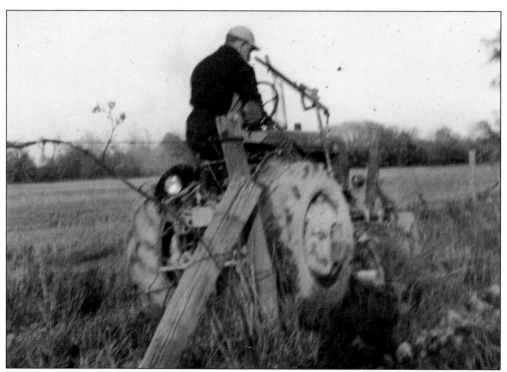

The farm that is now home to 6 Mile Cellars was established by Jonny Meaheen in 1900. He grew grapes and fruit trees, including apple, pear, peach, and plum. As a child, Leonard Lewis Towell worked for Meaheen. Towell purchased the property in 1942 after Meaheen passed away. Towell, shown here on a tractor in 1955, is the grandfather of winery owner Bart Towell. (Sherri Towell.)

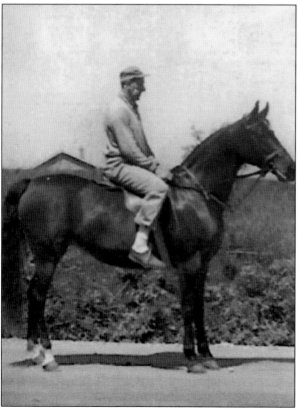

Leonard Lewis Towell loved horses, and at one time, he owned five. The majority of them were registered quarter horses. Towell did not work, race, or show them. They were just his "babies," and he cared for them until their deaths. The last one passed in the late 1970s. Towell shows off one of his prized horses in this 1955 photograph. One can see the barn that would become 6 Mile Cellars in the background. (Sherri Towell.)

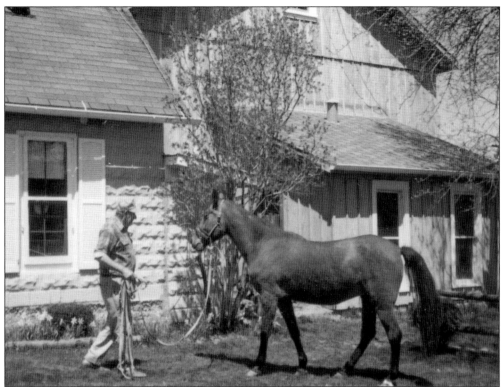

This photograph, taken in the 1970s, is of the horse barn on the Towell property. The barn itself was moved to its current location in 1900; it had originally been built on an adjoining farm. In the early 1950s, the packinghouse (beside the barn) was converted into living quarters for the family. Today, the packinghouse is the home of 6 Mile Cellars Winery with the accompanying tasting room being located in the barn (right). (Sherri Towell.)

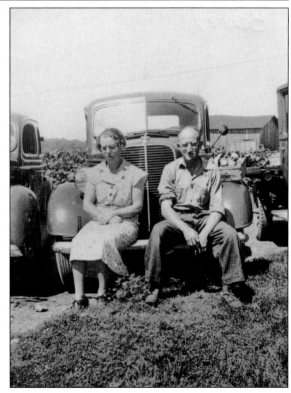

Burch Farms Winery was founded in 2009 on one of the oldest farms in the state. It was 1779 when Elliot Burch first took up residency on 25 acres of land on Sidehill Road in North East, Pennsylvania. Many, many years later, Florence and Herbert Burch would run Burch Farms, which would grow to about 250 acres. They are seen here sitting in front of their new car at the Burch homestead. (Catherine McClure Collection.)

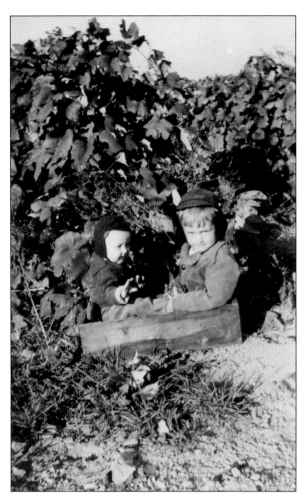

Douglas and Catherine Burch, the grand children of Florence and Herbert Burch, are seen here playing in the grape vineyards at Burch Farms in 1948. Today, the children of both Douglas and Catherine, Timothy Burch and Thomas McClure, are managing partners at Burch Farm Country Market and Winery. (Catherine McClure Collection.)

In 1939, Herbert Burch and his son James joined in partnership and continued on the same operation for several years. Herbert gave the farm a name, which had lacked a written one before this. He called it Northern View Farms H.C. Burch and Son. In this 1948 photograph, Herbert and his crew harvest grapes while future Burch Farms owner Douglas rides in the crates for some good farm fun. (Catherine McClure Collection.)

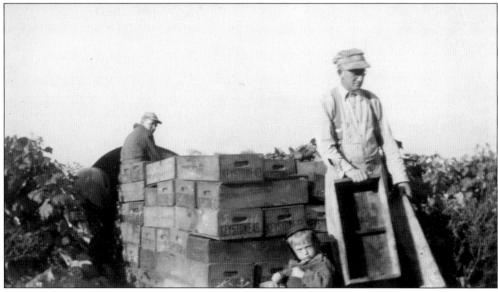

James C. Burch is seen in this 1940s photograph on the Burch Farms tractor. James expanded the farm to 200 acres and focused on producing grapes, apples, peaches, and cherries. He also expanded the chicken business, which was started by his father, Herbert. When James took over the business, he purchased the first "apple truck" that was needed to haul quality Burch fruits to the markets. (Catherine McClure Collection.)

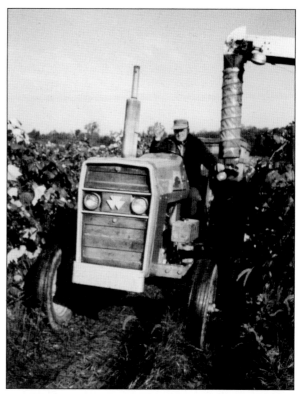

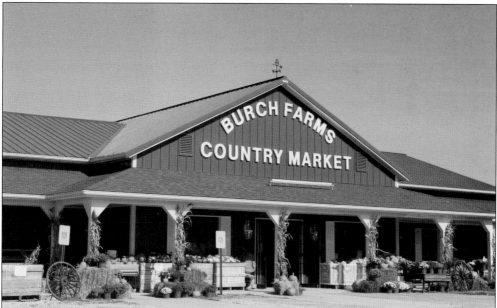

Douglas Burch became the owner of Burch Farms in 1986, and he and his son Timothy became partners. Tim is the sixth generation to run the farm. In 2000, Burch Farms pressed its own cider for the first time, and in 2005, the Burch Farms Country Market opened. The 5,000-square-foot market features a bakery and is an outlet for quality Burch fruits. Burch Farms opened a winery, which features fruit wines, in 2009. (Julie Pfadt.)

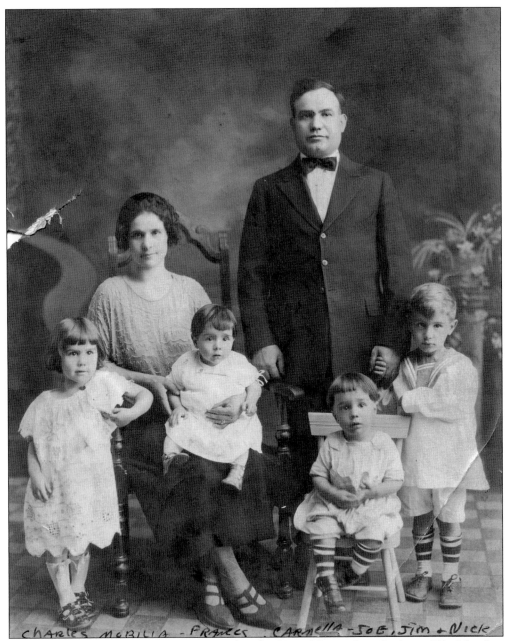

CHARLES MOBILIA - FRANCES CARMELLA - JOE, JIM + NICK

Carmelo and Fortunata Mobilia immigrated to the United States from Sicily via Ellis Island in 1920. They initially settled in Erie, but when Fortunata was diagnosed with asthma, they decided to settle on a farm in North East, Pennsylvania. They purchased 68 acres of land and started Mobilia Fruit Farms. Carmelo (Charlie) and Fortunata are seen here in the mid-1920s with four of their children (there would be a total of nine). (Nancy Hersch Collection.)

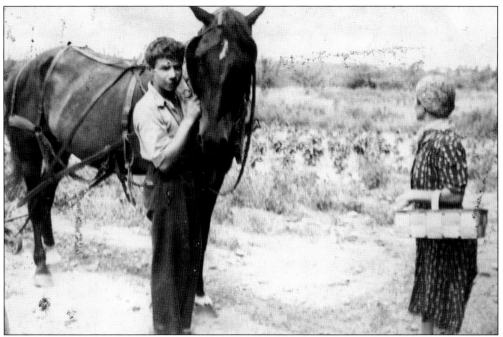

Louis Mobilia, one of the children of Carmelo and Fortunata, is seen here with his mother in the early 1940s. At that time, their farm horse was instrumental in working their large fruit farm on which they cultivated peaches, cherries, wheat, corn, and grapes. (Nancy Hersch Collection.)

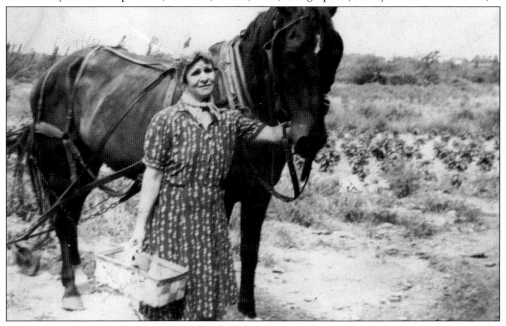

Fortunata Mobilia was no stranger to hard work on her North East farm. She is visible here in the 1940s with her workhorse, ready to plow. The Mobilia's packaged grapes in four- and eight-quart baskets and took them to the rail yard to be shipped to New York City and Chicago. Packaged grapes were only the beginning for Mobilia Fruit Farms. The farm was so productive, they decided to open a farm stand so they could sell their produce. (Nancy Hersch Collection.)

Louis Mobilia is seen here in 1948 while taking a break from plowing (now with a tractor instead of the old farm horse). The young man is holding a bottle of what appears to be grape juice, although it could be soda of some kind produced at a nearby soda manufacturing plant. (Nancy Hersch Collection.)

Carmelo "Charles" Mobilia poses at his fruit stand on the north side of Route 20 in North East with an unidentified visitor in 1953. Mobilia brought with him from Italy a love of wine and of the winemaking process. He made homemade wine for many years. (Nancy Hersch Collection.)

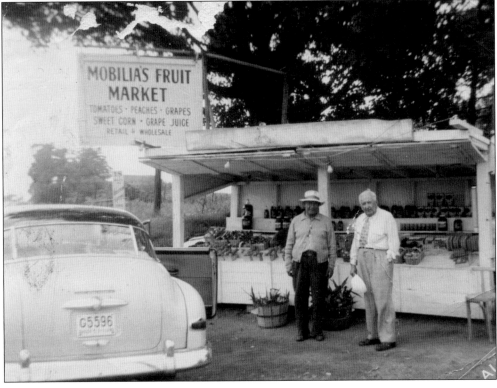

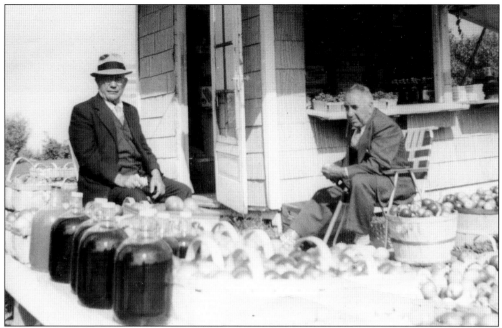

Charles Mobilia (left) took pride in his produce and in his farm market, and he usually wore a suit, tie, and hat while he worked. He is visible here in 1957 at his fruit stand. There are several carboys full of grape juice at the bottom of the frame. At that time, Mobilia sold his grapes to Keystone in North East and they used them to make the grape juice seen here. (Nancy Hersch Collection.)

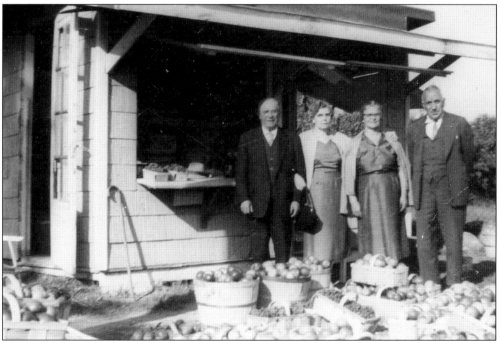

Charles Mobilia (far left) and his wife, Fortunata (third from left), pose with unidentified friends in front of their fruit stand in 1957. Notice the bushels of apples, baskets of grapes, and Charles's hat sitting on the counter beside him. (Nancy Hersch Collection.)

One of Charles Mobilia's sons, Nicholas, started working on the farm in the 1940s. He purchased land nearby and began cultivating tree fruit, such as apples and cherries. The family continued to expand their farm and began to sell produce directly to supermarkets in several towns. (Nancy Hersch Collection.)

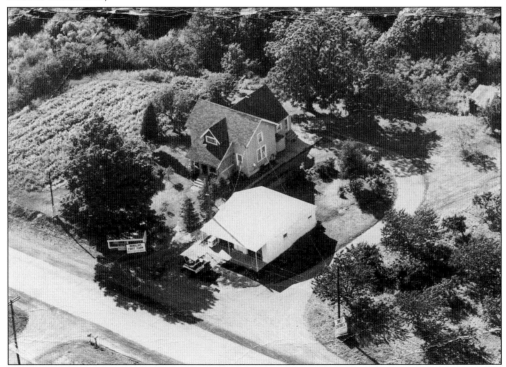

The Mobilia farm was the center of activity for the large family. Every Sunday, all of the relatives gathered and spent the day together. The house and original farm stand were on the north side of Route 20, across the road from where the Mobilia fruit stand and Arrowhead Winery is today. (Nancy Hersch Collection.)

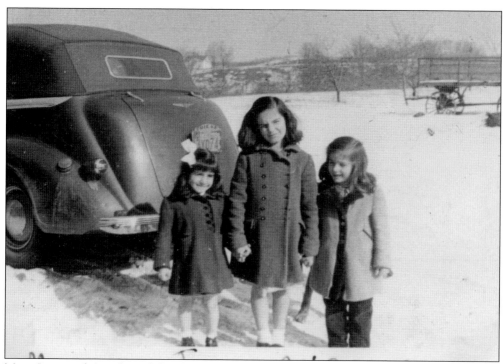

Mary, Josie, and Angela Mobilia, daughters of Charles and Fortunata, smile for the camera on a winter Sunday in 1952 on the Mobilia Fruit Farms. (Nancy Hersch Collection.)

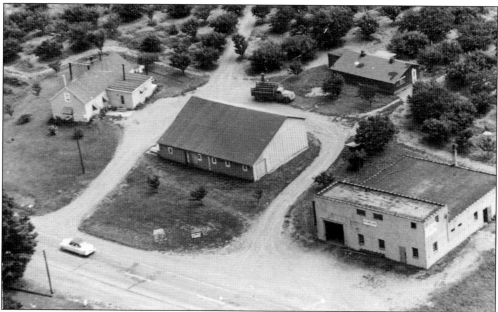

After Route 20 was widened and the original farm stand was torn down, the Mobilia family moved it to the south side of the road. This late-1960s aerial view shows the old facilities. Arrowhead Winery would be built on the real estate shown here. One of Carmelo Mobilia's grandchildren, Nicholas Mobilia, and his wife, Kathy, are now the owners of the Mobilia Fruit Farms. Their total acreage is currently about 250 acres. (Nancy Hersch Collection.)

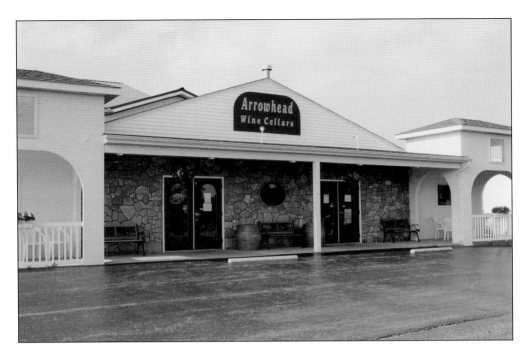

Over several years, Nick and Kathy Mobilia planted European, hybrid, and vinifera wine grapes. In 1980, they began to press grapes for many of the North East wineries. They opened their own winery, Arrowhead Wine Cellars, in 1998. Their winery features award-winning wines, with Nick and Kathy producing almost all of their wine from their own vineyards. In addition, they sell juice to nearly 60 other wineries in 15 states. (Both, Julie Pfadt.)

Six

CHAUTAUQUA COUNTY, NEW YORK WINERIES

Elijah Fay, the man who planted the region's first grapevines, produced the first Chautauqua County wine around 1830. The first commercial winery, Brocton Wine Cellars, was founded in 1859 by Joseph Fay, Garrett Ryckman, and Rufus Haywood. They sold the winery in 1865, and it became the Lake Shore Wine Company. The owners overextended themselves financially, including paying farmers extravagant prices for grapes. This led to the planting of more vines and high profits, but the inflation could not sustain itself. The winery went out of business, and the industry was demoralized. The many vineyards could not be abandoned, so growers sought to ship grapes outside of the region.

By the late 1870s, grapes were successfully being shipped via train and "grape fever" ensued. The enthusiasm for table grapes over wine grapes was due in part to sentiment for prohibition. Women active in the temperance movement influenced farmers to grow only Concord grapes because Concord was tolerated as an eating grape, while others were used only to make wine.

By 1904, about 27 organizations made wine, and—along with other individuals—they raised the region's total production to almost two million gallons annually. But Prohibition was finally made law in 1919, and local wineries were forced to close.

Following the repeal of Prohibition in 1933, the region's wine industry remained practically dead until 1960, when Frederick S. Johnson, a young agricultural expert, came home to Westfield. Johnson concluded that the future was in growing grapes for distinctive, dry wines. He replaced most of his father's 125 acres of apple and cherry orchards with wine grapes, and in 1961, he started the Frederick S. Johnson Vineyards Winery, which is the oldest estate winery in the state of New York.

In an effort to revitalize the New York wine industry, the state legislature passed the New York Farm Winery Act in 1976. This encouraged several new wineries to open, including Merritt Estate Winery in Forestville and, in 1980, Woodbury Vineyards in Fredonia. The Woodbury farm had been growing wine grapes since 1967. There are currently more than 13 wineries in Chautauqua County, attracting thousands of visitors each year and making an enormous economic impact on the region.

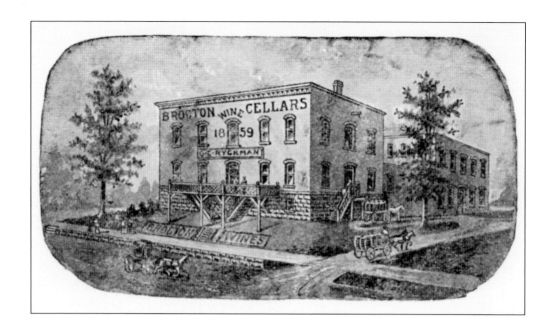

Chautauqua County's first winery, Brocton Wine Cellars, was founded in 1859 by Joseph Fay, Garrett Ryckman, and Rufus Haywood, who operated the winery until selling it to the Lake Shore Wine Company in 1865. When Lake Shore's owners overextended themselves, that operation failed. Eventually, Garrett Ryckman repurchased the winery property and began operation as the G.E. Ryckman & Son Winery. Ryckman incorporated in 1905 and changed the name of the winery to G.E. Ryckman Wine Company. Despite the loss of the building and approximately 500,000 gallons of wine in a devastating fire, Ryckman rebuilt the winery, but he eventually decided to sell the business and retire to Florida, where he invested in a railroad and lived very well for the remainder of his life. The above postcard is from around 1890, and the copper plate image below is from around 1869. (Both, John T. Slater Collection.)

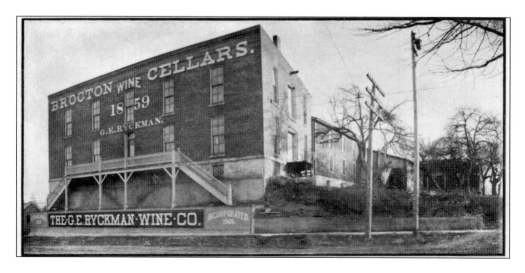

This wine jug was likely created in the 1880s at the G.E. Ryckman Wine Company in Brocton, New York. The building in which that winery was housed underwent many incarnations. Ryckman would incorporate in 1905 and begin operation under the name G.E. Ryckman Wine Company, producing about 300,000 gallons of wine per year until a devastating fire destroyed everything except the front facade on November 1, 1907. (Vincent Martinois Collection.)

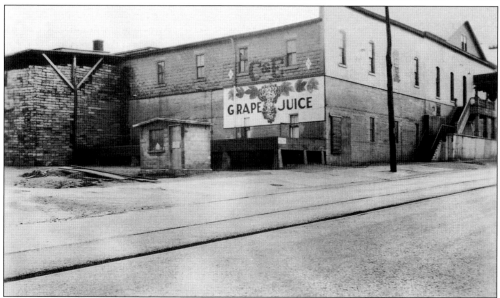

The structure that was once Chautauqua County's first winery would be expanded and remodeled by subsequent owners, including the Brocton Fruit Products Company and the C&E Grape Products Company. The latter company would be purchased by Jack Kaplan in 1933 and operated as a juice-processing facility called National Grape Corporation. Kaplan would go on to purchase the Welch Company in 1945. (Grape Belt Resource Network Archive.)

This late-19th-century glazed jug with a stenciled name and 1895 vintage date has survived from the Lake Erie Wine Cellars in Westfield. This winery, operated by J.D. Davis, was well known for its fruit brandies. It was destroyed by fire on December 30, 1908, reportedly set by tramps. (Vincent Martonis Collection.)

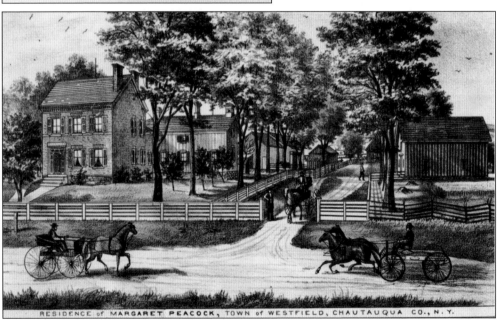

This sketch appeared in the Chautauqua County Almanac of the 1850s. William Peacock, the original land agent for all of Western New York, chose this farmstead for his family. In 1822, he had the house built as a wedding gift for his niece Margaret. One hundred forty years later, it became the home of Johnson Estate Winery. The house is still in existence at 8419 US Route 20 in Westfield, New York. (Johnson Estate Winery, Westfield, New York.)

A wraparound porch was added to the Johnson house in the late 1800s. This photograph was taken around 1900 when the house and farm was still owned by the Peacock family. (Johnson Estate Winery, Westfield, New York.)

Frederick Johnson (1877–1960) was an orphan and English immigrant who arrived in Westfield via Canada and Cornell University where he studied entomology. He settled on the Peacock farm in Westfield in 1908. He is seen here in 1945. (Johnson Estate Winery, Westfield, New York.)

This 1914 photograph shows the house on the left and two barns. The Johnson house, the building at far right, was torn down to make way for the farm's cold storage facility, which is now the tasting room at the Johnson Estate Winery. The facility was said to have been built using timber from an 1860s dairy barn found on the farm. (Johnson Estate Winery, Westfield, New York.)

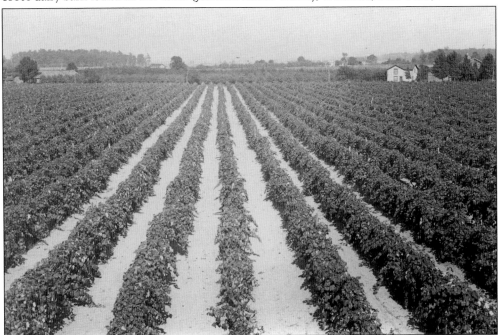

The farm that Frederick W. Johnson named Sunnyslope Fruit Farm consisted of apple, cherry, and peach orchards, along with a number of vineyards, predominately Concord. Family lore also credits him with the unofficial start of the winery during Prohibition, when he made wine from his homegrown grapes in the basement of the farmhouse. (Johnson Estate Winery, Westfield, New York.)

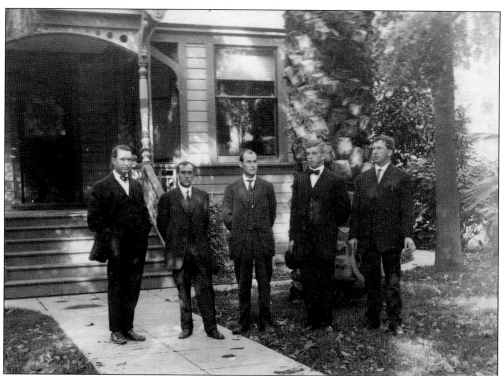

Frederick W. Johnson also worked as an entomologist with the Department of Agriculture in both Washington, DC, and in North East, Pennsylvania, where he met his wife, Nan Scouller. In this photograph, Fred stands second from the left with colleagues at the North East Experimental Station. At a time when insect infestation and disease were constant threats to the local grape crop, Johnson worked tirelessly to figure out how to best combat these enemies and grow quality fruit. (Johnson Estate Winery, Westfield, New York.)

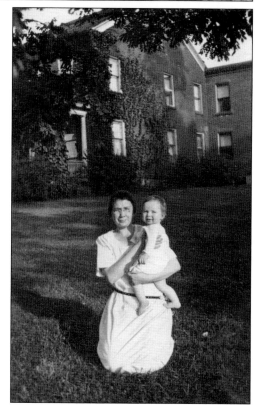

The wife of Frederick W. Johnson, Nan Scouller, of North East, Pennsylvania, and her son Frederick Spencer Johnson are visible in front of their home at Sunnyslope Fruit Farm in Westfield in 1922. (Johnson Estate Winery, Westfield, New York.)

Frederick Spencer Johnson (1921–1998) grew up on the farm his father purchased in 1908. He served in World War II as a naval aviator and graduated from Cornell University in 1946 and later worked in both Hawaii and in South America for Nelson Rockefeller in various agricultural endeavors. (Johnson Estate Winery, Westfield, New York.)

In 1960, after his father died, Fred Johnson returned to Westfield, New York, and the farm. He proceeded to remove the aging fruit orchards and a majority of Concord grapes. He replanted the estate with various French-American hybrid grapes and Native American varieties of Ives and Delaware—all suitable for making wine—and opened the winery in 1961. (Johnson Estate Winery, Westfield, New York.)

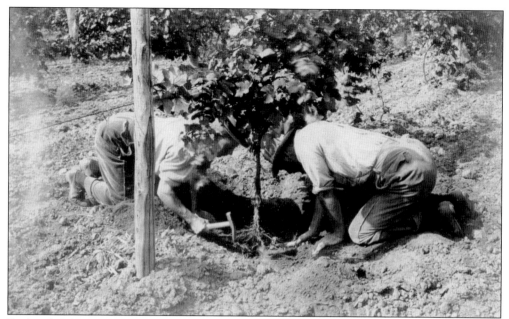

Frederick Johnson was a true husbandman and also a pioneer, as he was amongst the first in the area to plant wine grapes on a commercial basis. As a result, his winery is the oldest estate winery in New York State. To be an estate winery means that farmers grow their own grapes the way the winemaker wants them to be grown, from start to finish. (Johnson Estate Winery, Westfield, New York.)

This is Johnson Estate Winery as it appears today. It is housed in the building that used to serve as the farm's apple storage facility. Johnson Estate Winery was founded in 1961, and it is the oldest estate winery in New York. Quality is monitored from bud to bottle, with every detail carefully crafted. Johnson Estate's 200-plus-acre farm boasts 115 acres of grape vineyards where 13 varieties of wine grapes are grown, including four Labrusca, six French-American Hybrids, and three vinifera. Award-winning wines can be sampled here seven days a week. (Julie Pfadt.)

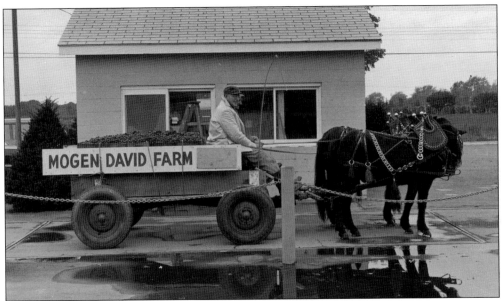

Bourne Street in Westfield is home to the Mogen David Winery, makers of kosher Concord wine. The company started as the California Wine Company in Chicago in 1933. In 1941, it was known as the Wine Corporation of America. In 1947, the name was changed to Mogen David. Its most popular wine is MD 20/20, also known as "Mad Dog 20/20." It made good sense for them to move to the largest Concord grape region in the world. (Patterson Library.)

Gary Burmaster's great-grandfather Rufus Butler established some of the region's first grape vineyards in Sheridan, New York, in the 1860s. The Burmaster farm has been a productive grape farm ever since. After years of selling their fine grapes to other wineries, wine-loving Gary and Pam Burmaster and their daughter Beth decided to expand their operation to include a winery. Liberty Vineyards & Winery opened in February 2008. All of the grapes used in Liberty Vineyard's wines are grown locally (most are grown right on the winery property). They now produce 23 wines and take great pride in nurturing their grapes and wine from the moment they trim the vines to the moment the cork is sealed in the bottle. (Julie Pfadt.)

The modern building on Route 20 in Westfield, New York, stands in juxtaposition with classic European style and Old World winemaking skills. The Mazzas have been making wine in the region for over 40 years. Their wines are award winners, and their beautiful tasting room is a sight to see. The new Mazza Chautauqua Cellars and Five & 20 Spirits is also Western New York's only distillery, producing Apple Eau de Vie, Cherry Eau de Vie, Grappa of Steuben, Grappa of Vidal Blanc, Pear Eau de Vie, Pear in the Bottle, rye whiskey, and specialty vodka. They also have a microbrewery on the premises. (Julie Pfadt.)

Quincy Cellars, which opened in 2007, derived its name from the former name of a hamlet near the winery's location in Ripley, New York. Its tasting room and retail area is located in the original stone cellar in a 125-year-old, three-story barn. The main floor features a fresh space for private events, such as wedding receptions and corporate meetings. It also has a beautiful outdoor pavilion for special events. (Julie Pfadt.)

Located just across the road from Quincy Cellars in Ripley, New York, Sensory Winery and Art Gallery stands as a tribute to both wine and art. Paintings from several celebrated local artists are on display in the Sensory tasting room, making it a unique and exciting destination. (Julie Pfadt.)

Situated on a quiet country property that boasts 22 acres of wine grapes and several ponds, Sparkling Ponds Winery in Ripley, New York, produces delicious wines in a friendly and unique setting. The winery was founded in 2005, and five years later, the current owner purchased the business. At Sparkling Ponds Winery, one can take their time, peruse the gift shop, or stroll around the grounds and enjoy viewing the rustic scenery and the many ponds. (Julie Pfadt.)

Vetter Vineyards Winery was established by the Vetter family in 1987 and purchased by Mark and Barbara Lancaster in 2003. The tasting room is in the original farmhouse on a gorgeous hillside estate on Prospect Station Road in Westfield, New York. Most of the grapes used in Vetter's wines are grown on the 100-acre estate. Twenty different varieties of grapes are harvested, including Riesling, Chardonnay, Pinot Noir, Shiraz, and Zweigelt. (Julie Pfadt.)

Merritt Estate Winery is nestled in the hills on the east end of Lake Erie Wine Country, in Forestville, New York. It was established by William Merritt in 1976 on a farm that had been in his family since the 1860s. William Merritt still runs the farm and winery with the help of his son Jason. Merritt wines have won prestigious awards, and the winery holds outstanding festivals and special events. (Julie Pfadt.)

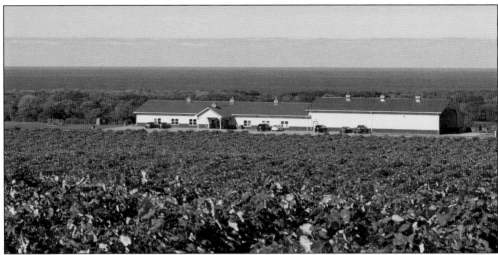

After experimenting with winemaking for almost 15 years, grape grower and wine enthusiast Pete Noble opened Noble Winery in 2006. The large winery sits high on a hill overlooking a valley full of grape vineyards and great Lake Erie to the north. On a clear day, visitors can sit on the long outdoor patio and see Canada across the lake. The large tasting area was designed to entertain many, and it does. (Julie Pfadt.)

The 21 Brix Winery was opened early in 2011 at the Olde Chautauqua Farms in Portland, New York. The farm was purchased by the Jordan family in the 1960s and has become the largest wine grape farm in the region. Varieties of wine grapes grown on the farm include the following: Chardonnay, Pinot Gris, Riesling, Gewurtztraminer, Cayuga, Seyval, Vidal, Cabernet Sauvignon, Cabernet Franc, Noiret, Syrah, Lemberger, Pinot Noir, Niagara, and Concord. Although a new winery, experienced winemaker and owner Kris Kane has earned numerous awards. (21 Brix Winery.)

Don and Rosalind Heinert purchased their 72-acre farm in South Ripley, New York, in 1991. Because their farm features hundreds of organic blueberry bushes, they named it Blueberry Sky. The Blueberry Sky Winery was founded in 1998 as a family project and an outlet for the Heinerts' adventurous wines. They create unusual wines that will fascinate both chefs and foodies alike. (Julie Pfadt.)

Willow Creek Winery opened in 2000 in Silver Creek, New York, on the easternmost end of Lake Erie Wine Country. Since then, the grounds, entertainment, and wines have all evolved into a successful, exciting amalgamation that keeps visitors returning again and again. A unique and wonderful experience at Willow Creek does not end in the new, rustic tasting room. Outside there are 26 acres of fruit trees and bushes, vineyards, streams, wooded areas, and a pond where visitors are welcome to pick and eat the organic fruit, fish, hike, or sit and relax with a glass of their favorite wine. (Julie Pfadt.)

Established in 1980, the Woodbury Vineyards Winery was built on the Woodbury family fruit farm, which was originally settled in 1910. In the 1970s, Robert and Gary Woodbury began to plant new varieties of grapes, including Chardonnay, Riesling, and Cabernet Sauvignon. The majority of Woodbury's dry wines are aged in oak barrels, giving them a smooth, distinct flavor. Their Brut sparkling wine is still carbonated the old-fashioned way, by riddling, which means the winemakers turn each bottle a quarter turn every day. (Julie Pfadt.)

Seven

ERIE COUNTY, PENNSYLVANIA WINERIES

Just as Elijah Fay was both the first to plant grapes and to make wine in his county, the same can be said for William Griffith, the man credited for establishing the grape industry in Erie County, Pennsylvania. Griffith encouraged local farmers to grow grapes, and when the supply outgrew the demand, he built a winery. The South Shore Wine Company opened in 1864. They hired an Ohio winemaker named John E. Mottier who, after fulfilling his contract with them, opened his own winery.

Griffith also left South Shore and started his own winery, the Griffith Winery. Other wineries opened in North East before Prohibition, including the Lakeview Winery, the Grimshaw Winery, and a few small operations owned by notable grape growers like Alonzo Butt, Frank Randall, and D.C. Bostwick.

Prohibition, beginning in January 1920, closed the area's wineries, and its repeal in 1933 would not be enough to encourage a regrowth of the wine industry. The Pennsylvania Liquor Control Board (PLCB) was formed by the state to discourage alcohol consumption and to create a monopoly on all wines and liquors. It remained illegal for private commercial wineries to sell wine directly to the consumers.

In the 1960s, a renewed interest in wine spread throughout the country, including Pennsylvania. It was fourth in grape production with almost all of it coming from Erie County. Concord grapes were still a profitable crop, but in 1965, a bumper crop demonstrated the need for diversification. Growers desired to plant wine grapes. Wine enthusiasts wanted to open wineries—but the PLCB stood in the way. In 1966, the first Pennsylvania Wine Industry conference was held. A movement was born, and a group of pioneering individuals, including Doug Moorhead from North East, pushed legislators to pass the Limited Winery Act in 1968, which allowed wineries to make wine from Pennsylvania grapes and sell it in limited quantities to the public. In 1969, Moorhead opened Presque Isle Wine Cellars. Penn Shore Vineyards also opened that year.

Now more than a dozen wineries thrive in the western end of the Chautauqua-Erie Grape Belt, known as Lake Erie Wine Country. Thousands of tourists each year enjoy award-winning wines and beautiful scenery, creating an enormous economic impact for the region.

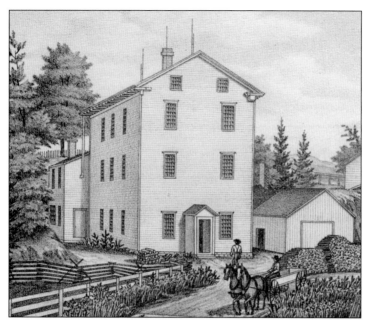

Benjamin Grimshaw moved to North East, Pennsylvania, in 1861 where he cofounded the Cass & Grimshaw Woolen Mill just off Orchard Beach Road near Lake Erie. This drawing was included in the 1876 Atlas of Erie County, Pennsylvania. The building burned down in 1883, and on its foundation, the Grimshaw Winery was constructed. It opened in 1906 and produced wine until Prohibition was instated in 1920. (Chas Wagner Collection.)

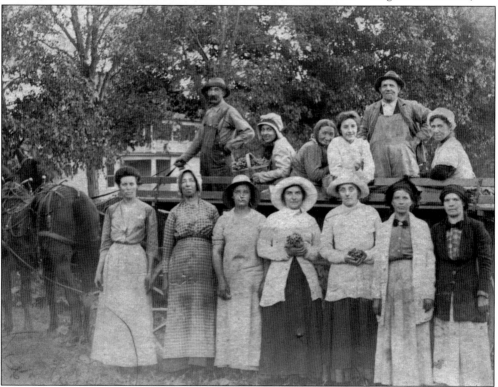

This undated postcard says, "Grimshaw Winery." The photograph on it was taken between 1906 and 1920 when the Grimshaw Winery was in operation in North East, Pennsylvania. At that time, there were at least two other wineries operating in North East Township: the South Shore Wine Company and one owned by D.C. Bostwick. According to the research of Carl Haeseler, the Grimshaw Winery was the only one using waterpower. (Chas Wagner Collection.)

This is the January 1919 wine list from the Grimshaw Brothers Winery in North East. In January 1920, Prohibition, known informally as the Volstead Act, took effect and "forbid the manufacture, sale or importation of intoxicating liquor or beverage purposed in the US or its territories." (North East Historical Society.)

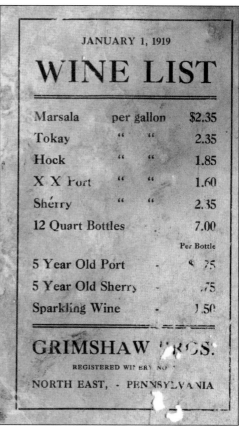

JANUARY 1, 1919

WINE LIST

Marsala	per gallon		$2.35
Tokay	"	"	2.35
Hock	"	"	1.85
X X Port	"	"	1.60
Sherry	"	"	2.35
12 Quart Bottles			7.00

Per Bottle

5 Year Old Port	-	$.75
5 Year Old Sherry	-	.75
Sparkling Wine	-	1.50

GRIMSHAW BROS.

REGISTERED WINERY NO.

NORTH EAST, - PENNSYLVANIA

The fifth generation of Grimshaws still lives on the property in North East Township. Chas Wagner, great-grandson to William Grimshaw, recently unearthed this XX Port bottle on the property. (Julie Pfadt.)

After Prohibition took effect in 1920, federal government enforcers showed up at the Grimshaw Winery and dumped 50,000 gallons of wine down Orchard Beach Run. After making sacramental wines for a time, the winery closed and slowly turned to ruins. This is a 1940s photograph of what remained of the winery on the Grimshaw property. (Chas Wagner Collection.)

William Grimshaw had three children: Robert, Ben, and Esther. This is a 1943 photograph of Robert Grimshaw with Rose Grimshaw Boyd and her two children, Roselyn and Robert. Robert Grimshaw was the grandfather of Chas Wagner, who now lives on the Grimshaw homestead. (Chas Wagner Collection.)

This photograph was taken on the Grimshaw property around 1943. From left to right are Jane Grimshaw, unidentified, Richard Wagner, Leona Grimshaw Wagner, Beulah Smith Grimshaw, Robert Grimshaw, Rose Grimshaw Boyd, and Helen Grimshaw. (Chas Wagner Collection.)

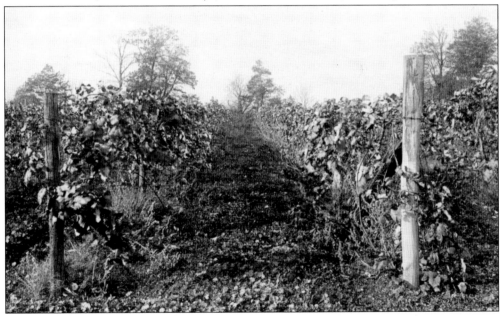

The first grape variety planted by William Griffith was the Catawba grape because it was a great table grape and was also good for making wine. Griffith encouraged many people to grow grapes in North East, and eventually there were not enough markets to which the grapes could be sold. His solution was to build a winery to utilize the abundance of local grapes. (North East Historical Society.)

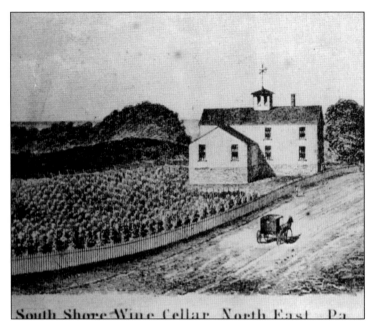

This 1860s sketch was produced the same year that the *North East Star* reported that Griffith was planning to spend around $100,000 to increase his vineyards and build a large wine cellar, which would be the first wine cellar in Erie County. For unknown reasons, this winery failed, but Griffith secured financial backing and established the South Shore Wine Company on the same property in 1864. (Mazza Family Archives.)

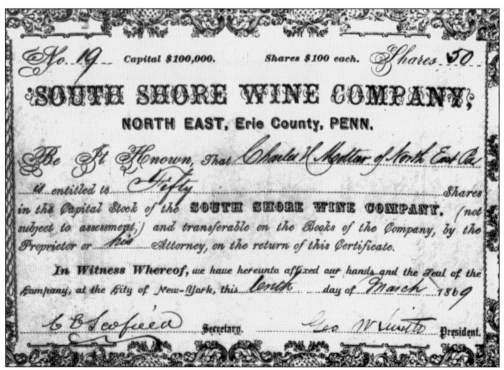

Griffith was in partnership with (among others) New Jersey native Col. J. Condit Smith. Smith had served in the Civil War as quartermaster of the Army of Tennessee before he retired. During his service, Smith befriended a man named John W. Foll, who served as chief of the 15th Illinois Army Corps under the command of Colonel Smith. (North East Historical Society.)

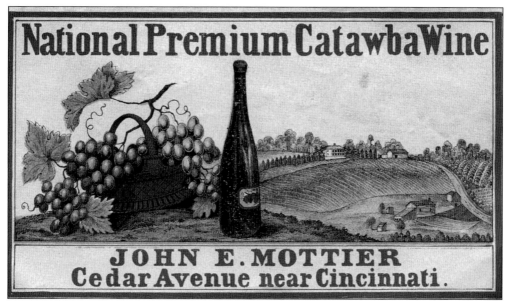

National Premium Catawba Wine

JOHN E. MOTTIER
Cedar Avenue near Cincinnati.

The dismal profits from the winery's first year were unsatisfactory to the shareholders, so in September 1865, Colonel Smith, then president of the South Shore Wine Company, offered John E. Mottier, a well-known, quality winemaker in Ohio, shares of stock in return for five years of service as their winemaker. Mottier was born in Switzerland in 1801 and immigrated to America in 1821. *The Erie Gazette* referred to Mottier as "the Wine King of America" and announced that the "very best and purest wine" would soon be available. This is a label from Mottier's Ohio Winery. (North East Historical Society.)

After his obligatory five years with South Shore, J.E. Mottier and his son Charles, shown here, started their own winery: the J.E. Mottier Winery in North East, near Middle and Orchard Beach Roads. The winery was renamed Chestnut Grove Winery. After John's death in 1887, Charles continued with the winery operation until around the turn of the century. (North East Historical Society.)

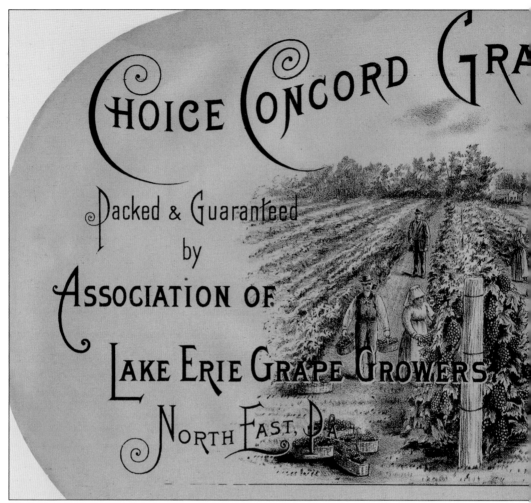

CHOICE CONCORD GRA...

Packed & Guaranteed
by
ASSOCIATION OF
LAKE ERIE GRAPE GROWERS
NORTH EAST, PA

John E. and Charles Mottier left South Shore Wine Company and established their own grape farm, their own winery, and even their own basket factory. In 1897, the Mottiers made over a

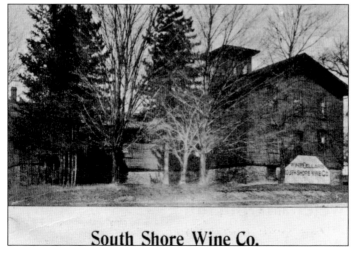

South Shore Wine Co.

Colonel Smith's trustee, Samuel Smith, sued for ownership of the South Shore Wine Company in 1875. He ran it until his death in 1883. The winery changed ownership several times over the next few decades. John Foll was involved with the winery in various ways until he retired in 1915. This postcard shows the South Shore Wine Company in 1906. (North East Historical Society.)

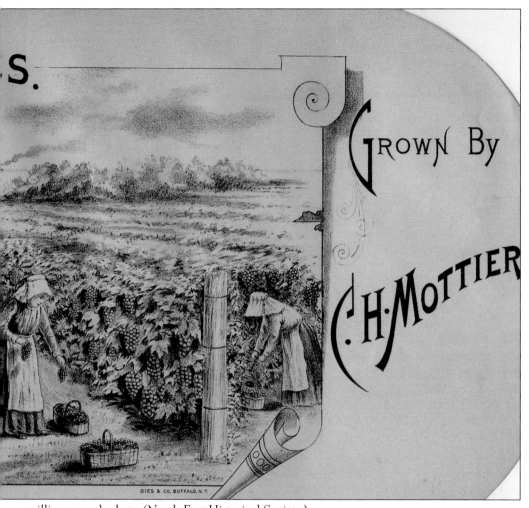

S.

GROWN BY C.H.MOTTIER

GIES & CO. BUFFALO, N.Y.

million grape baskets. (North East Historical Society.)

The last person to manage the winery until Prohibition closed it down was Katherine Davidson, widow of owner Roscoe Davidson, who was the last licensee of South Shore in the 20th century. In 1922, the building that once housed one of Pennsylvania's first wineries was opened as a hotel and restaurant renamed the South Shore Inn. This is a 1929 photograph of the inn. (Mazza Family Archives.)

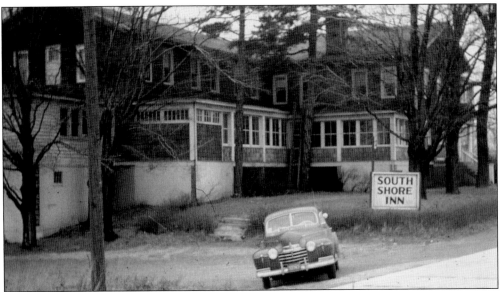

The evolution of the historic building continued throughout the 20th century. This is a photograph of the South Shore Inn in 1949. The wine cellar was closed, but the inn enjoyed a bustling tourist trade. (Mazza Family Archives.)

The sprawling building that was once the South Shore Wine Company underwent several reincarnations as a restaurant or banquet hall or a bar and sometimes all of the above until it closed in the early 2000s. It sat empty, its beautiful stone wine cellar filled with garbage and mostly forgotten. It was not, however, forgotten by North East winery owner Robert Mazza. (Mazza Family Archives.)

Robert Mazza purchased the building in 2005 and painstakingly restored it to its former glory. In 2007, it reopened as a sister wine operation to Mazza Vineyards. The South Shore Wine Company remains open for wine tastings in the cellar that was first opened by William Griffith in 1864. During the summer season, visitors can enjoy the upstairs café and relax in a beautiful, wide, and screened-in porch while enjoying award-winning Pennsylvania wines. (Mazza Family Archives.)

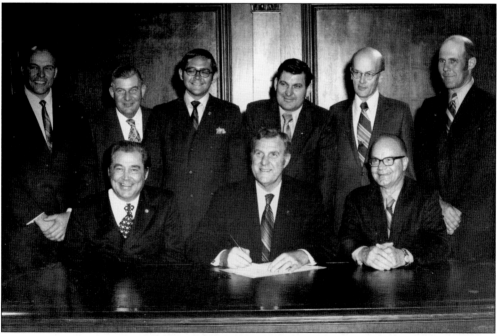

Then Pennsylvania governor Raymond P. Shafer (seated, center) signs the Pennsylvania Limited Winery Act in 1968. The law allowed wineries to sell limited amounts of wine directly to consumers (originally 50,000 gallons). Prior to the passage of the act, wineries were permitted in the state, but they had to sell their wines through the Pennsylvania Liquor Control Board, a legal state monopoly that governs all alcoholic beverages. Also in the photograph in the second row are P. Blair McCord (far left), George Luke (second from left), and George Sceiford (far right)—all of whom went on to open Penn Shore Vineyards in North East. (Jeff Ore Collection.)

Construction on Penn Shore Vineyards Winery in North East, Pennsylvania, began in June 1969. It received its license on the same day as Presque Isle Wine Cellars, making the two wineries the first to open in the state following the passage of the 1968 Limited Winery Act. Three friends, all grape growers, opened the business together. P. Blair McCord was president, George Luke served as vice president, and George Sceiford was the secretary-treasurer. (Jeff Ore Collection.)

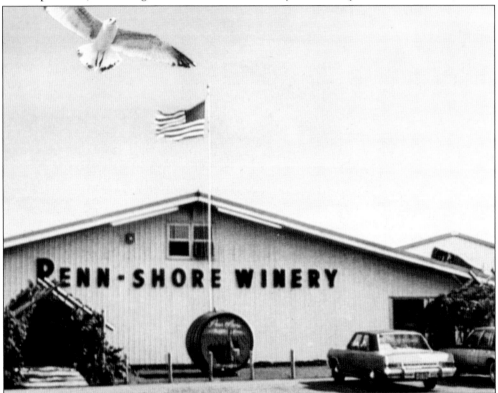

Penn Shore Vineyards Winery began pressing grapes for wine in September 1969. It opened for business in April 1970. Touted as "Pennsylvania's only major winery," the original building was 5,400 square feet. The owners installed stainless steel tanks with a capacity of 40,000 gallons, and they purchased enough redwood and oak barrels to hold 16,000 gallons of wine. (Jeff Ore Collection.)

This is the original tasting room at Penn Shore Vineyards Winery in the early 1970s. The winery marketed seven wine varieties in its first year. This winery also has the distinction of producing Pennsylvania's first champagne, now known as sparkling wine. Ten varieties of grapes were used in the champagne, but their winemaker, David Theibeau, kept those varieties a secret. The winery produced 2,400 bottles of champagne its first year. (Jeff Ore Collection.)

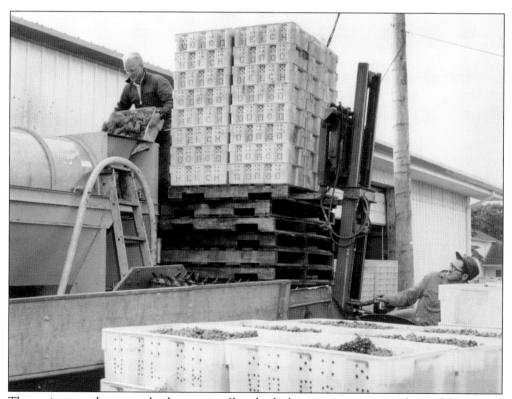

These winery workers are unloading crates of handpicked wine grapes into a crusher and de-stemmer behind Penn Shore Vineyards Winery around 1970. The juice from the crushed grapes would then be collected and placed in tanks for fermentation. (North East Historical Society.)

Penn Shore Vineyards Winery president Blair McCord hailed from a long line of North East grape farmers. He is shown here in an undated photograph (probably from the mid-1970s) with an early model of a mechanical grape picker. McCord was also a partner in developing the CMH Harvester, used for small vineyards. He is the "M" and partners Earl "Pete" Clark and Jim Holmes are the "C" and "H." (Jeff Ore Collection.)

Marketing wine in a region unknown for its wineries sometimes required creativity. In 1975, Penn Shore Vineyards Winery held a contest where they awarded a bottle of wine to the 100th bearded person to visit the winery. It was the 1970s after all. This photograph shows the winner of the contest receiving his free bottle of wine. (Jeff Ore Collection.)

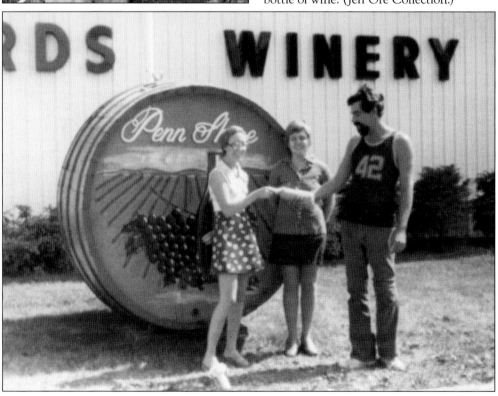

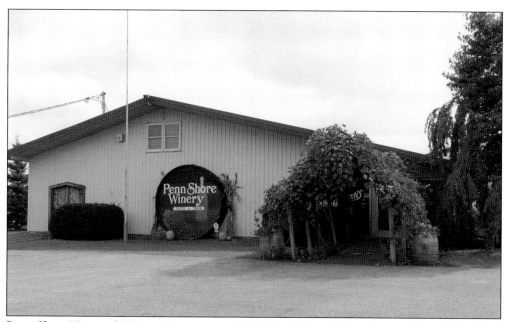

Penn Shore Vineyards Winery is now owned by Jeff and Cheryl Ore, who purchased the winery from Robert Mazza in 2004. Located on picturesque Route 5 in North East, only a few hundred yards from Lake Erie, Penn Shore Vineyards Winery offers award-winning wines, free tours, and a gorgeous gift shop. (Julie Pfadt.)

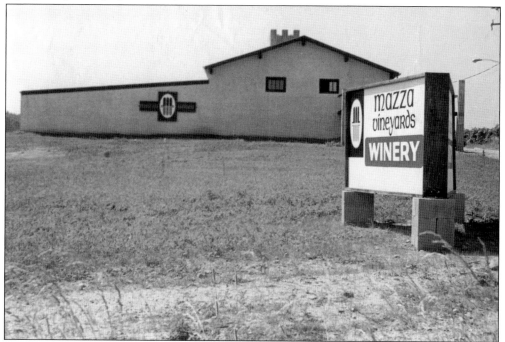

In 1954, Joseph Mazza left Calabria, Italy, to settle in the United States. A year later, he sent for his wife, daughter, and sons Robert and Frank. They moved to North East, Pennsylvania, and discovered they were in an ideal grape-growing region. Robert and Frank built and opened Mazza Vineyards Winery on Route 5 in North East in 1973. (Mazza Family Archives.)

This early-1970s photograph shows the detail and design Robert and Frank Mazza put into complementing their Mediterranean-style winery. (Mazza Family Archives.)

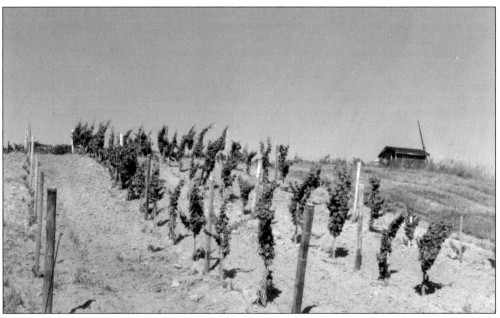

This is a preliminary vineyard planted on the Mazza property in the early 1970s. With its close proximity to Lake Erie, Mazza Vineyards enjoys the region's cool offshore breezes, sandy soil, and the plateau-like topography, which creates an ideal growing condition for classic wine grapes and European hybrids. (Mazza Family Archives.)

Here, Frank Mazza operates a grape press in the winery in the mid-1970s. Although one might expect Italians to make Italian wine, the region's climate is most suitable for Germanic grape varieties. Robert brought in a talented German winemaker who taught him how to make excellent Germanic-style wines. As early as 1974, wine tasters from across the country unanimously selected Mazza's as their top choice in a blind lineup of five Johannesburg Rieslings. (Mazza Family Archives.)

This is the original Mazza Vineyards tasting room. The photograph is from 1974, before the long tasting bar was added. Robert Mazza is visible selecting his award-winning wines for tasting. In 1979, Frank Mazza left to start another winery in Lancaster, Pennsylvania, and Robert continued to expand the winery operations. (Mazza Family Archives.)

This is the original retail area in the tasting room at Mazza Vineyards in the early 1970s. Mazza was the first Pennsylvania winery this side of Canada to create ice wine, a rare and distinct wine that results from pressing grapes while they are still frozen. (Mazza Family Archives.)

Mazza's Special Edition Vidal Blanc wine was selected for the 1988 christening of the third reconstruction of the tall ship *Niagara*. The ship was launched in Erie on the 175th anniversary of the Battle of Lake Erie. Mazza Wines have been served to governors and presidents, and Mazza Vineyards continues to earn international recognition for its wines. (Mazza Family Archives.)

Chancellor, Chardonnay, White Riesling, and Baco Noir were some of the early wine varieties produced by Mazza Vineyards, as shown here in this early-1970s photograph. They also offer sweeter wines from the native Niagara, Concord, and Catawba grapes. Cabernet Sauvignon and Chambourcin have also become popular selections. (Mazza Family Archives.)

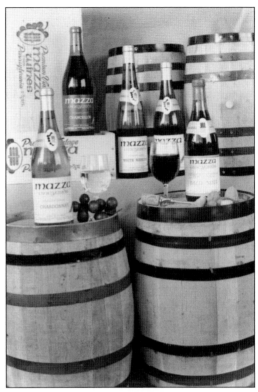

Today, Robert Mazza, wife Kathie, son Mario, and daughter Vanessa carry on the family tradition at Mazza Vineyards in North East, Pennsylvania, one of the premier wineries in Pennsylvania. They have expanded the wine list to include some dry red classic Italian varietals, Gruner Veltliner, Muffa Nobile, Cream Sherry, Ports, and much more. (Julie Pfadt.)

Sam and Becky Best opened Lakeview Wine Cellars in North East, Pennsylvania, in May 2008. They had been home winemakers for 30 years before deciding to share their unique wines in a commercial setting. Sam creates his wines using only grapes that are grown within a two-mile radius from his winery. All of Lakeview's premium varieties are fermented in Pennsylvania white oak barrels. (Julie Pfadt.)

A new winery to the Lake Erie Wine region, Arundel Cellars & Brewing Company opened early in 2014 on Route 20 in North East, Pennsylvania. Owners carefully restored a beautiful late-19th-century barn, which for three generations had been operated as a cider mill. They own 150 acres of vineyards and apple orchards and also produce hard ciders. An in-house microbrewery offers food and a gorgeous setting in which to sit and relax. (Julie Pfadt.)

Courtyard Wineries opened in 2010 by seven wine enthusiasts who had a dream and a vision to provide a unique tasting experience for every guest. Courtyard Wineries's stunning facility offers two tasting rooms and two very different brands of wine. Its impressive LaCourette line is more refined, appealing to more traditional wine enthusiasts. For those tasters who want to have some casually sophisticated "fun" with their wine, Courtyard offers their Barjo Bons tasting room. Barjo Bons literally means "crazy friends," and these unique flavors will help create fun times and memorable experiences. (Julie Pfadt.)

Heritage Wine Cellars is housed in an 18th-century barn with a long history in the Lake Erie Wine Country region. Local historians believe that it was Rev. William Bostwick who, in the early 1700s, brought the first Catawba grapes to North East, Pennsylvania—years before the family farm was founded in 1805. The farm thrived for generations, and then in 1976, Heritage Wine Cellars was founded by master winemaker Robert Bostwick, who was, at the time, a fifth-generation grape farmer. Today, the North East winery is managed by Robert's sons Josh and winemaker Matthew Bostwick. (Julie Pfadt.)

Douglas P. Moorhead's father, Douglas M. Moorhead, was a longtime Concord grape grower in Harborcreek, Pennsylvania. The younger Moorhead graduated in 1956 with a degree in pomology from Penn State University, and then he served in the United States Army. While stationed in Germany, Doug became interested in vinifera grapes. Upon returning to his farm, he helped his father introduce the first *Vitis vinifera* grapes in the Lake Erie area in 1959. He also led the industry by experimenting with over 200 European and hybrid grape varieties to determine which ones would thrive in the Lake Erie appellation. (Julie Pfadt.)

Doug opened his business in 1964, not as a winery, but as a supplier of grapes, juices, supplies, and equipment for home winemakers, making Presque Isle one of the oldest winery suppliers in the country. Doug was instrumental in getting the Pennsylvania Limited Winery Act passed in 1968, and Presque Isle received one of two limited winery licenses first issued in 1969. Presque Isle's award-winning wines can be found in the Isle House, where the tasting room and gift shop are located. (Julie Pfadt.)

DISCOVER THOUSANDS OF LOCAL HISTORY BOOKS FEATURING MILLIONS OF VINTAGE IMAGES

Arcadia Publishing, the leading local history publisher in the United States, is committed to making history accessible and meaningful through publishing books that celebrate and preserve the heritage of America's people and places.

Find more books like this at
www.arcadiapublishing.com

Search for your hometown history, your old stomping grounds, and even your favorite sports team.